George Strawbridge

phlogs:

Journey to the heart of
the human predicament

For Patti

We gather at night to celebrate being human.
Sometimes we call out low to the tambourine.

RUMI

Phlogs:
Journey to the heart of the human predicament

Published by People's Press
Post Office Box 70
Woody Creek, Colorado 81656
www.PeoplesPress.org

People's Press Mission
*As the world becomes increasingly global, the need grows for
community and for the cultivation of community identity through
artistic insight. People's Press will search for books and the means
to publish and distribute them to this purpose.*

People's Press editorial board
Mirte Mallory
Nicole Beinstein Strait
George Stranahan

Library of Congress Control Number: 2009904476
ISBN: 978-0-9817810-3-7

Written by George Stranahan & Nicole Beinstein Strait
Book design by Rainy Day Designs

Typeset in Perpetua and Bulletin Typewriter
Produced by Hudson Park Press, New York
Printed by Doosan Printing, Korea

FOREWORD

These phlogs are pieces from the picture puzzle of my life, the puzzle that I never will complete. In fact I never even found the edges. I have many people to acknowledge for the disarray, too many to recount either here or anywhere else. If I tried to spill them out I'd probably start with Hutchy; even in kindergarten his teeth were yellow scuzz, his family knew nothing of toothbrushes, yet he smiled and mercifully sat next to me on the school bus.

My "Best Buddy" in grade school was Tommy Boeschenstein; he was Doctor Ubdub to my Doctor Phlubdub, today we would have been correctly called nerds and shunned as we were then. Tom was a photographer, and so I became one too, begging for Christmas an Argus C3 camera. Ubdub was into the technicalities of photography, Dr. Beers formulas for paper developer, pinacryptol green for film processing. Together we graduated ourselves to view cameras and sheet film with pretensions of the ƒ64 world of Ansel Adams and Edward Weston. Sonny Ayers encouraged us and arranged a little show in the basement of the Toledo Museum of Art.

About 1965 I decided I would be a better person if I learned to like martinis. Each night, returning from the university, I would drink a very cold martini, and lo! The next year I decided that a better person was one who liked sardines. Not quite the slam-dunk of the martinis, but King Oscars in mustard sauce and on saltines made me that better person. Three years ago I decided that a taste for poetry would improve my mind. I read poetry now, and have yet to enjoy a whole poem. What I enjoy are slices or slivers shaved from a poem, I call them slyphs.

A fragment, like a miniature work of art,
has to be entirely isolated from the surrounding world
and be complete in itself like a porcupine.

FRIEDRICH VON SCHLEGEL

These slyphs are literary loners, set apart from the world because they are worlds unto themselves. They are like porcupines, bristling with prickly philosophical spines. Rub them the wrong way and you are in for a surprise.

Mirte Mallory, friend, curator, without her sense of order these fragments would be puzzle pieces without context. If you make out any murky shape or line here you and she have both succeeded. GSS

Words become our representation of our perceived reality, and we constantly check, through conversations, our reality against the reality of others. Our realities are relative, our words are relative, thus our words to express our realities are doubly relative. It's a double bind. But we need to do our best, to struggle, to muddle forward. No, I think we do it for ourselves, for our own sense of being real, and not imaginary or insane.

<div align="center">George Secor Stranahan</div>

When I was six years old or so and living in Hong Kong, I designed my first book. It was the story of a family: a father, a mother, and three children, the youngest adopted. I crayoned a portrait of each family member on separate 8"x11" lined pages and wrote a few sentences to describe each of them. I stapled the pages together, included a title page, and hence, self-published my first manuscript. Around the same age I also wrote down a list of all the roles I wanted to play when I grew up, and there were at least 30 careers considered. I wish I had those documents today.

Since then, I have journeyed to become everything I hope to be, even if my clarity and road have darkened along the way. Throughout my elementary years and early summers I performed in school and camp musicals. From there, and in the following order, I have functioned as: a varsity field hockey captain, founder of a mentoring program, and yearbook editor at Horace Mann High School in Riverdale, New York; a psychology major and founder, producer, actor, and director for a theatre company at Cornell University; an actor for an Off-Broadway summer theatre program; a pre-medical student at Columbia University; a bookstore clerk; a researcher and project manager for the development of an In Vitro Fertilization Center; an MBA graduate of and commencement speaker for the Yale School of Management; a summer intern for a fund of hedge funds; a healthcare management consultant; a first employee and operations director for an internet start-up; a front desk attendant for a resort/conference center; a retail bank manager; a consultant for a digital arts studio; a development director for a nonprofit affiliated with an Academy Award-winning documentary; a development officer for a community foundation; and, finally, as a real estate copywriter; all before George Stranahan miraculously found me and hired me as a writer for his website and this book. Our kindred peripatetic spirits had somehow recognized each other.

Although I have authored two novels, two plays, one screenplay, and a collection of poems, nothing until now has ever been published or available to the public. So thank you, George, for believing. Thank you for helping me to realize my childhood dreams, and through my writing, the enduring ability to discover as many lives as my imagination can imagine. Thank you Mirte and Danielle, also fellow artists and great spirits; thank you Sidney Hyman for your generous insight; thank you JP and Ruby for my beautiful life; and thank you for the bright future.

Nicole Beinstein Strait

March 22, 2009
Redstone, Colorado

PHLOGOSOPHER. The mind behind the eye.

An Appreciation by Ralph STEADman

*'It is only as an aesthetic phenomenon that existence and
the world are permanently justified'.*

FRIEDRICHE NIETZSCHE

SNAP! That was all it took to encapsulate a world of possibilities inside a nano-slice of all that is there in infinite space. We see it every day but we don't notice. Countless solutions from a troubling point of view open up new possibilities that, once opened, will never be innocent again. But then, from the very instant of opening these pages I was looking at an exposed life, a secret until now, a long exposure contained and only waiting for the light.

I am overwhelmed by these photographs that were rescued from some watching moment by George Stranahan during a long, eventful and significant life. I was unprepared for what I discovered. I did not expect philosophy or lessons in living life – which I guess is philosophy writ large. Each picture became a revelation and a small nugget of self-knowledge that I presumed I knew already. But each revelation was a moment of renewal. Seamlessly woven into these pictures are hints of things, people and places that I know already. The spirit of my old friend, Hunter S. Thompson as a neighbour, the golden autumn of Aspen trees across the valley which is still a part of an idyll called Woody Creek, the Brigadoon of my life that I thought would last forever. And now it cannot be trusted to be there anymore as a symbol of purity in a world gone wrong.

With a name like George, how can anything be right? George asks, not with a whine but with a puzzled wince. Maybe if there had been someone at his school called Ralph life would not have been torture to his sensitive soul. But the name Ralph served me well and when I met Hunter, my name was spat out of his mouth like a bark – an integrated necessary ingredient in his psychic need to blame and curse. If my name had been Trevor there would have been nothing to grab hold of – so I saw the blessing in it.

Much of the raw response in George's world is a personal cry for justice, not merely for himself but for the cry of others. He gravitates toward pain and puzzlement, whether it is from a sheep or a Nepalese child. His photographs reach out to the other side and look from the opposite direction trying simultaneously to touch the mystery of what one cannot see physically at that precise moment … Goddammnit! If George wasn't trying so hard to explain to himself why his memories of life hit on him so bad, he could have been an all-American Cubist! If he wasn't so anchored by day to day pain in others, a new found selfishness would release the trapped and tortured artist struggling and tearing at his innards to escape and go on the rampage. He has been living madness by proxy, maintaining a privacy within his beating heart and masking a raging

cauldron of un-distilled pure spirit – his own apparent beautiful and peaceful countenance – that he observes in nature while fully understanding the ravaging destructive power that produced it. He will not have it. George understands too much, questions everything, trying even to disprove the Gaia principle of the Universe's self-regulating processes (or so I reckon!), in order that he may save what is left of humanity's precious parts, passing them on as sum total of what he has felt throughout his life. He is indeed the Outlaw he hopes he is but that Outlaw lives in hiding and on the run through some wonderful landscapes of his own creation deep inside himself.

The game's up, George! It is time to come out and show us this world you have been preserving, not only for yourself, but for the others, though you are not like the others. That is the important difference. In an attempt to hide that fact, you are allowing this glimpse of yourself and your pain to be shown as though it were something quite unnecessary and unimportant. Handed in nervously like a school exam paper you wait for retribution because you feel that perhaps it wasn't what was expected or called for. Well, you are right! It was completely unexpected – and utterly beautiful. It is time to kick ass with more – to let go and be the blooded Outlaw you are, only now – in broad daylight!!

Ralph STEADman: 13.00 hours. Old Loose Court. 9/14/2008

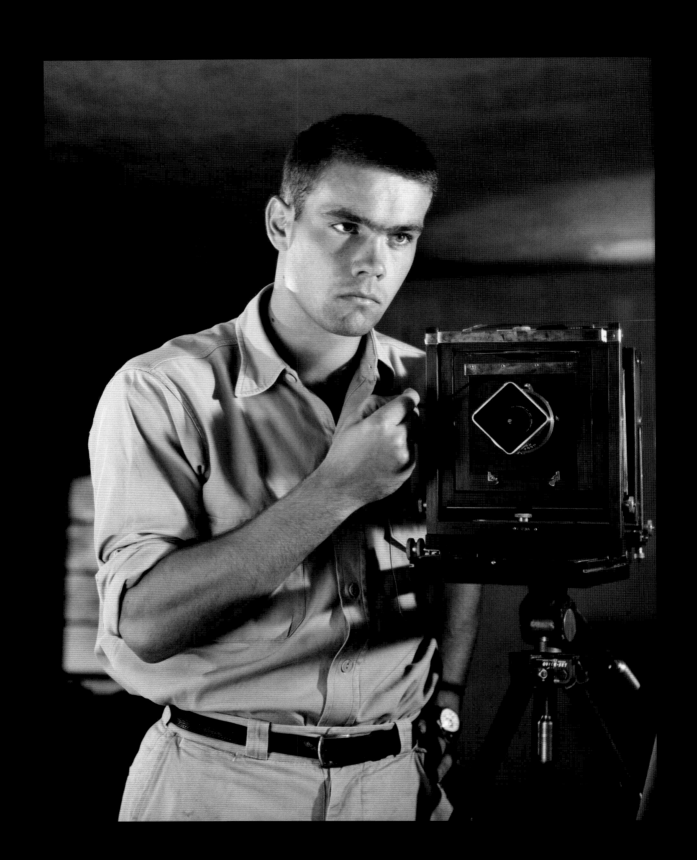

WELCOME

I began making photographs about 1942, and in those days that meant black and white film, mixing chemicals and lots of time in the darkroom. I thought photography made a solitary but harmless hobby but was not the serious kind of work that I understood my parents or the world at large with all its mystery of womanhood expected of me. And so I attempted serious things and made photographs as I bungled along.

Today I find myself on the downhill side of life and wonder sentimentally what that hill was all about and did I do it justice … As I look at my photographs now I think that perhaps they are the serious work of my life and a roadmap of whatever that damn hill was. What you will find here are my phlogs where words and photos come together (collide with each other) Nicole Beinstein Straits' chapters giving her view of the situation, and odds and ends too fierce to mention.

It always was a pilgrimage, a journey to the heart of the human predicament. A predicament is a difficult, perplexing, or trying situation: a position imposing hard or unwelcome choices, sometimes with a lack of freedom to do what one would prefer.

—•◆•—

Won't you come into the garden?
I would like my roses to see you.

Richard B. Sheridanzc

1. ESSENTIAL LONELINESS

The lensed light focused on silver halides provides a representation of reality, in the darkroom chemistry we learn to exaggerate to get the point across. Computers and ink jet printers have added a new dimension to our ability to exaggerate, and we have a renewed capacity to get the point across. And the point is? There are more questions than answers. If there are answers at all, there are no easy answers. The word predicament applies to almost anything that is interesting. Words and images have no absolute meaning; they are entirely relative to the observer. I am and I am becoming; I am what I not yet am. The extraordinary is best found in the ordinary.

I recently heard George described as "the biggest heart in the Valley." I also recently heard George describe himself as an alien. "It's part of morality not to be at home in one's home. It's part of morality to not just say this is my home and it's wonderful, and cozy, and warm," he says. "It's the pilgrim shit — still seeking and searching. There's no there there for a pilgrim."

I began photographing at age 11 with my mother's Leica IIIg and moved through 2¼ x 3¼, 4 x 5, 5 x 7 and 2¼ x 2¼ formats through my college years. I was published and exhibited in *Engineering and Science Magazine, Newsweek,* the Boston Metropolitan Museum, the Toledo Museum, and others. Believing that the decent woman of my desire would eschew marriage to a photographer, I instead pursued the career of a physicist.

During that career, which lasted until age 40, I continued to photograph mostly in large format and inanimate subject matter. Paul Strand, Ansel Adams, Paul Caponigro, and particularly Edward Weston were my models, and there is a considerable body of this sterile work. Looking back, I see a lonely young man carrying heavy large format equipment (alone) to places where there were no people. There is a thread of people, family, children, that flicker amongst the stones and trees, a faint promise of understanding.

More than by any of George's professions or passions, which include, but are not limited to: physics, photography, ranching, community organizing, education reform, social venture entrepreneurship, publishing, mountaineering, and beer and whiskey-making, it is by how George fashions his life that he will be remembered.

As the civil rights and anti-war movements swept through universities and liberal intellectuals I rediscovered the 35mm format and even the 16mm Minox format and produced informal, intimate and very personal photographs of life as lived on a day-to-day matter. The diaries of Samuel Pepys were the model for this very spontaneous work — banal he called it.

Another 30 years were spent as educator and farmer, but also as observer/photographer, using all the former formats except Minox and 5 x 7. The work became more documentary than either scenic or banal; what's going on here, how do we understand this? The eye never sleeps; that time we call sleep the brain is sorting,

filing, and storing the images of a lifetime and arranging them in little photo essays we call dreams. Work was exhibited in Aspen and Woody Creek and published in Mountain Gazette.

In his self-proclaimed elder role, George began reflecting on his life and contemplating his death about three years ago. Now at seventy-seven, he is opening himself to being caught, as much as a successful outlaw will allow.

Successful outlaws have been chased at one time or another and have enjoyed the chase. A chase is exciting for both the chased and the chaser. My mother didn't share Rousseau's belief that the natural child is innocent, she believed the contrary. Her assumption about her own six children and fifteen grandchildren was that they were up to no good, needed to be watched carefully and caught before they perpetrated the evils on their minds.

My mother told me about the time that she and her brothers decided to kill their mother. An old saying is "Boiled tea is spoiled tea." The intent is to remind us that the boiling water is poured over the tea leaves and left to cool to drinking temperature; the tea will be bitter if returned to the stove. Apparently the children had amplified the saying into "boiled tea will poison;" and so they had boiled their mother's tea and watched in fascination as she drank it down, waiting for her to keel over. And she didn't.

I came to believe that my mother had to catch me because I would do the same; at least metaphorically, boil her tea. And I pushed the rules, explored exceptions, became skeptical, learned how to get into the liquor cabinet and the gun chest, and other places in the house where secrets were kept.

After my insistent prodding about when he was going to share his stories with the world, George accepted my proposal to help with getting his words out there. With hundreds (perhaps thousands) of printed and digital pages filled with essays, science lessons, letters, recipes, plans, quotes, organization charts, stories and philosophical meanderings, I was handed responsibility of organizing his writings and correspondences to tell the tale.

Looking back, nay even looking now, the work is a study of innocence, childhood, and loneliness, essential loneliness. I say that I know you, but that isn't true. I know only myself, I merely relate to you, and it gives some relief to that essential loneliness.

The structure for this memoir-of-sorts is a patchwork dialogue that unravels, as one peels an onion, stripping away at who George is through his dense and variegated writings. Through an organic discovery process, I began to see how an individual life expands in more dimensions than linear ones. As the chapters now posted on George's website evolved (which I have truncated for this book), a mirror to my own life emerged; I was finding myself too, and witnessing first-hand George's role as an angel investor. In venture capital verbiage, an angel investor is someone who provides seed capital for a start-up, which George has certainly done over the years — but it also implies profit, and financial, not societal or spiritual, returns. In the cyber world, the angel refers to the investor, not the one who is being invested in. But George imagines himself an authentic angel investor. He invests in angels, and allows them to flourish so they can

perform their duties unhindered by external, monetary pressures — a luxury that he was gifted by his family many years ago.

We know, scientifically, quite a bit about the origins of man, of the earth, indeed of the universe. Of course what science knows is about the regularities, the laws. Many scientists come to some variant of the belief that such regularities and laws must have a cause, and they may or may not speculate on the nature of that cause. I suspect that the very concept of cause is quite anthropomorphic and the idea that things could happen without cause is uncomfortable for humans.

What is becoming uncomfortable for George these days, however, is this self-promotion. When acting out the urge to share, he feels shame — and fear. In this day of memoir and reality show frenzy, he is self-conscious about unveiling his energies for public view. I wonder why revealing one's self would be scarier than hiking up the Baltoro glacier; why being at the mercy of other people's inane opinions is scarier than being at the mercy of nature's ruthless storms?

"My daughter Molly gave me a really nice line," George recalled in his poetic voice during one of our conversations in his Woody Creek barn. "This is a Leonard Cohen song: 'There's a leak in everything. That's how the light gets in.'"

You think you can see me when all the light is gone darkness on my side you will fall you fall you will how can you linger off into the sun if it doesn't shine (trust me) how can you feel light when it is all gone (Believe me) you can't so come (with us now) you better be ready to cross that line darkness is here (you won't be able to shine) (Believe us) When you are alone and you hear those footsteps (every place) you try not to believe (but they're here) to stay.

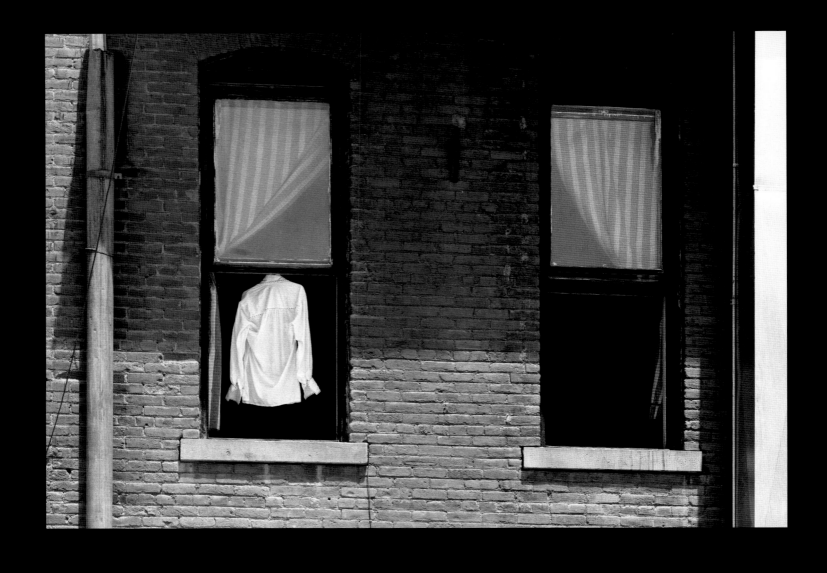

Scotty was born and raised in Aspen and moved into his mom's apartment after she died. Dad had been a mining claim grifter so down on his luck that he hired out as range rider for the North Thompson Cattleman Association. Scotty, now thirty five, has spent the last ten years on the city's road crew. Between high school and road crew he had an army career, rising to Sergeant before the dishonorable discharge. By his third beer at the J-Bar we expected and got the whine about "the injustice of military justice."

Scotty was a decent worker and could banter and joke with the best while raking hot asphalt. His comrades reckoned that he would eventually retire from this same job and while away his declining years at the Eagles Club with the same banter and the same whine about injustice. Surely he would never marry.

Who knows, nature or nurture, from whence sprang Scotty's dancing skills, but Lord he was a phenomenon Saturday nights at the old armory hall. As you know, there are women who want to dance and just leave it at that, so Scotty never lacked partners for Saturday night. Part of his attraction was the clean shirt and he didn't get drunk and never asked for anything more than the dance. The shirt caught good light on that dance floor and Scotty threw back his head in joy.

———•◦•———

We must be humble, for we are compassed by mysteries.

W.R. INGE

Alleys are the backside of our frontside; places of essential functions, exits more than entrances. The front entrance is a façade, the alley exit speaks truth to what goes on inside.

———•◆•———

The greatest mystery is in unsheathed reality itself.

Eudora Welty

———•◆•———

I went searching through the alleys of my mind, and there was no door, just a little window, reached by ladder, through which I wiggled through into the inside. And what did I find first thing I got in? Ashes, ashes of my soul, burnt, spent, but still warm and strangely aromatic ready to be shoved into the alley.

And there was my mother, unrepentant until she died, and over here my sister's young ashes, and what is all this $F = ma$ and Schroedinger's equation? It's dark back here and the ceiling is low. I found the bone fragment of a 5th grade chum, and a broken shard of God. And it was dark, you gotta feel your way around in the dark. And you bump into an old love, a tour in the army, a duck shot with my dad, and yesterday's sunset.

———•◆•———

Now that my ladder's gone I must begin where all ladders start,
in the foul rag-and-bone shop of the heart.

W.B. Yeats

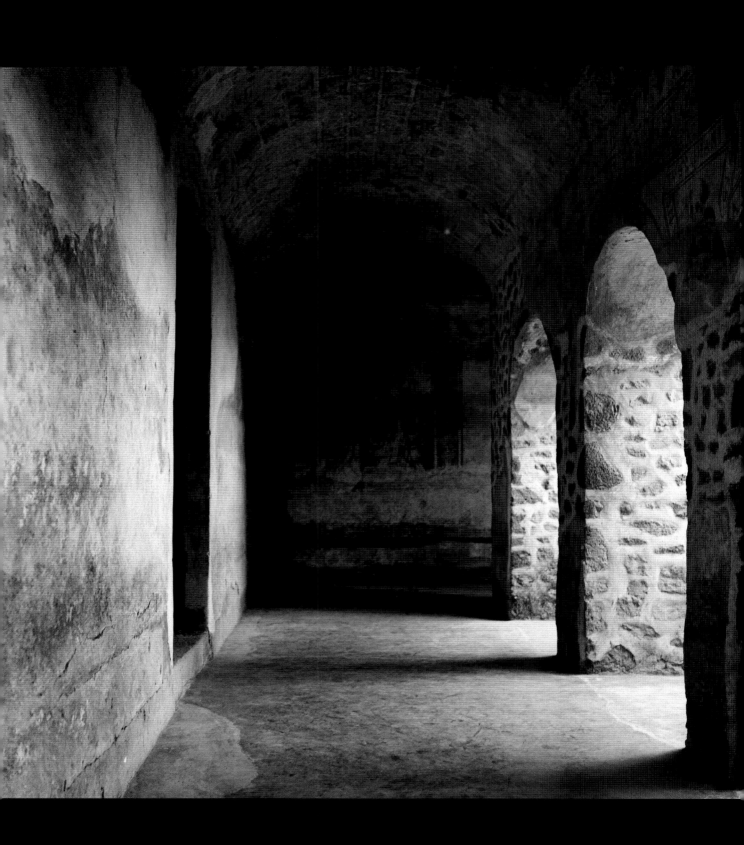

Angelina (does a name become it's own destiny?) entered the convent when she was thirteen. Padre Ramon spent many hours with her family explaining God's love for their daughter and his wish that she figuratively marry his only begotten son. Her father was opposed, being quite in love with her himself. Dads don't often win against such formidable competition. She and Padre got their way precisely because her dad did truly love her, and she moved into a small cell at the convent.

Prayers, prayers and more prayers. And supplication, it's about obedience, crawling around the courtyard on her knees. It's cold at night and her blanket is thin. Mother Mathilde said that visions of the Lord and thoughts of her future afterlife should be warmth enough.

Out to buy milk one day Angelina struck up a conversation with a street urchin. He had no family and called himself sometimes Juan, sometimes Johann and sometimes Julio. But he had a clear understanding of how the world works and how he found his own place in the world. He was comfortable, had friends, and went no place on his knees.

They held hands on the way to the market and then returned to their different spaces in their different worlds. They would meet again, and again over the years.

———◆———

And sometimes things like these go searching
along dark paths, and find trees there,
And blossoms in tall rain.

James Wright

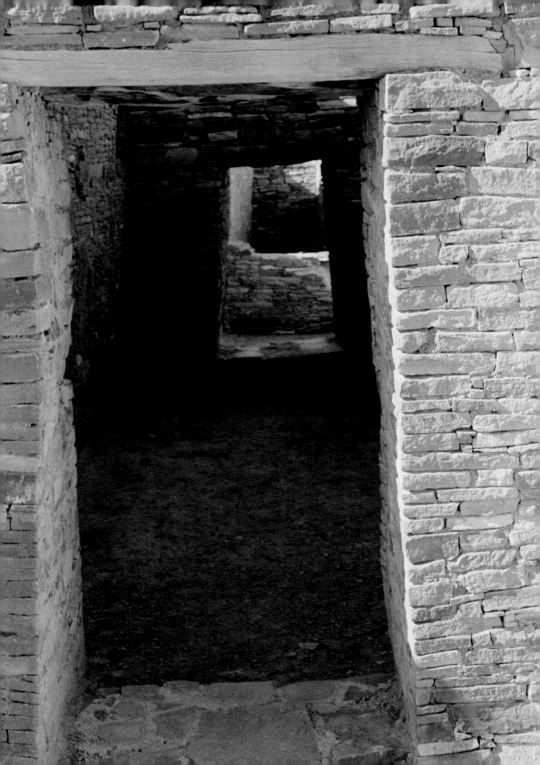

In the early days Bob was just another talented hippy. His talent was sheepskin clothing, and in those days the hippies that wore his jackets had a secret little pocket inside, by the armpit, to hold a few joints for the day's hiking, skiing or whatever. As the hippies disappeared so did the market for Bob's sheepskin products. He turned his attention and skills to building with stones, big things with big stones.

Bob drank a lot of bourbon and smelled of it. Women, beyond the occasional bar pickup, didn't find him charming, nor did he try. His talk gradually withdrew from the conventional conversations into his own world of stones and the mojo that he found within himself as he built with them and lived within them – alone, always alone. He lives here. No, don't go through the second door, turn right just past the first door and you'll find him in the dark corner mumbling and working and reworking his stones. Squat and listen for a while, nod approvingly, leave a bottle of Black Jack, and back to the daylight.

———◦•◦———

What is fate but the density of childhood?

RILKE

The palm reader was behind the second door, the one just right of the middle of the photo. Oh, she read Tarot cards too, but that seemed so much more a matter of random numbers than my own palm that has been with me all of my life — through thick and thin, you know. I was surprised that she pulled the shades so tight and how dark it became; how could she see the details of my palm?

She held my hand close and stared for a long time before speaking: "You are here to find out about your dog?"

"Yes, we called him Woody but his real name was Woodstock."

"And why do you think I can channel him through your palm? Can't you bring me his leash or his bowl; oh, or his ashes?"

"Excuse me ma'am, I'm sorry, but I seem to have come to the wrong place. You don't understand about Woody and I."

———◆◆◆———

Moderate lamentation is the right of the dead, excessive grief is the enemy of the living.

Shakespeare

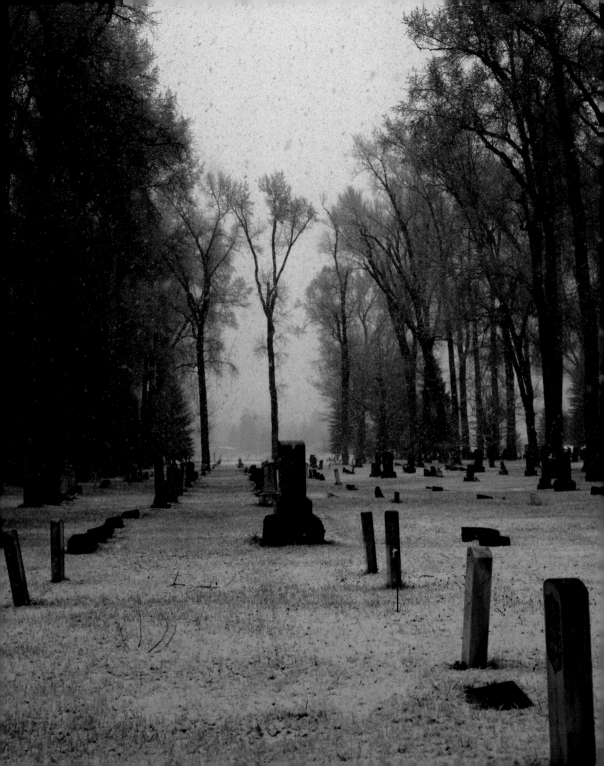

For me, here, there is something solemn, hushed, moving slowly and talking lowly; and yes, wonder. I wonder what it will be like to be dead myself, and that's surely a solemn wonderment. I imagine dead will equate roughly to extinguished. But is there something of me not extinguished, some tracks, a scent, signs that I passed through?

In January 1948, a plane wreck extinguished all twenty-eight farm workers who were being deported in the DC-3. Woody Guthrie read about this in the newspaper and was furious that the article didn't even include their names. He wrote a poem that was finally set to music in 1961. The chorus ends with:

> *You won't have your names when you ride the big airplane,*
> *and all they will call you will be deportees.*

No tracks, no scents. If Woody were alive today and reading of the events in Rwanda, Sudan and the Middle East, I imagine him singing, "all they will call you will be refugees." No tracks, no scents.

A mature cemetery will naturally have mature trees; they add grace to the setting in a world far too barren of grace.

——◆•◉•◆——

And I looked and beheld a pale horse: and his name that sat on him was Death.

Revelation 6:8

Celtic women were often warriors alongside their men and, like all Celts, celebrated life and its warfare with wild Druidic ceremonies of drink, dance and song. Brighid, named after the goddess and the wife of Aengus, was one such. As a warrior she was admitted to the noble class and thus conversant with the Druidic verses and the secret mathematics of the calendar that regulated the important holidays. Imbolg, which marked the earliest signs of the coming spring; Beltain, a time of community gatherings and moving of the herds to summer pasture; Lughnasadh to celebrate the ripening of first fruits; and Samhain to recognize the end of harvest, the time of sacrifice, and the lowering of the barrier between the world of the living and that of the dead.

The annual cycle was expected to repeat endlessly and always the same; the only change being the births and deaths as celebrated at Samhain. Only the actors changed, never the story. During one battle Brighid lay down her sword and said, "War no more." She was stoned to death and buried here with her torcs around her neck.

———◆———

Cushioning ourselves about with dreams, and hearing fairy-songs in the twilight,
we ponder on the soul and on the dead.

W.B. Yeats

Every mother's child has experienced, "Wow, being head over heels in love is such a rush." You could feel like you're dying from those breathless heart skips if you didn't know better. And it's true, triggering all those love neurotransmitters is indeed a rush, and it can become addictive. It's obvious that Angelina is a love addict. She's in love with everything immortal, heaven, Jesus, saints and angels. She has not seen her little street urchin friend, Juan, for quite awhile. We know that being in love with mere mortals can have its certain disappointments, but not so terrible as to be avoided altogether.

———◆•◆•◆———

If love is the answer could you please rephrase the question?

LILY TOMLIN

Here's what can happen when you, the dad, lose custody of the kids in the divorce. There's a once-a-month visitation, you have an evening with the kids and must return them "home" before their bedtime.

The closest airport is forty-five minutes away, so I pick the kids up at their new home in a rental car. The former is still pissed, redemption is remote, there are instructions, nay orders, "Don't let them eat any sweets and you'll be very, very sorry if you forget that the judge ordered you to never talk to them about this case." Indeed, and why would I? It's been a horrible disaster.

They already have some favorite restaurants in their new town and we dine at one or another. After dinner there's barely an hour left of the visitation. We park at an empty mall. We sit on a bench and struggle to find words to tell each other what this is really all about.

———•———

Allow me to walk between the tall pillars
And find the beginnings of one vine there,
Though I arrive too late for the last spring
And the rain still mounts its guard.

JAMES WRIGHT

This is Angelina's recipe for pico de gallo. One avocado, one tomato, one half yellow onion, one clove garlic, one half jalapeno pepper, the latter two ingredients finely diced. One half teaspoon ground achiote and juice of half a lemon.

Monkfish is mostly despised and at best only little prized in any cuisine: thin, soft and fishy smelling flesh inside of a tough and thick skin. Few find it worth the effort to extract the fillets and to marinate them in vermouth. The fillets are fried in butter, the marinade added for finish, and it is proper to drink some tequila reposada; in truth the tequila bottle should be empty by bedtime.

This very meal Angelina cooked for her father, and as he toddled off to bed she said to him, "Tomorrow I will make my temporary vows and receive my habit. I will then not be able to return here and cook for you ever again." As she cleaned up the kitchen she thought, "Why can I confess to myself that I am frightened, but not to my father?"

———•◦•———

The soul's at fault, which ne'er escapes itself.

HORACE

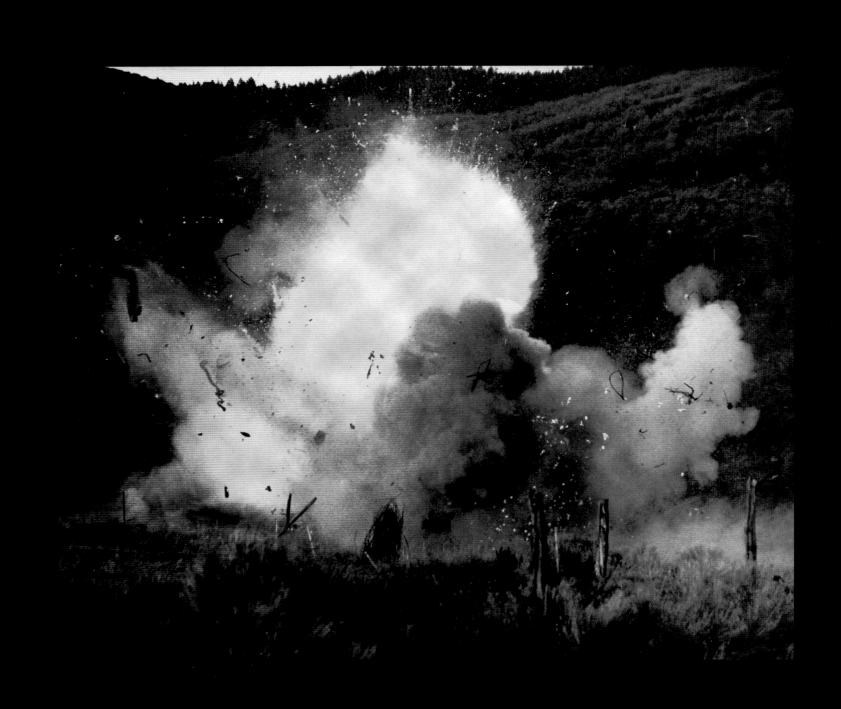

One of many lady friends left her Wagoneer behind Hunter's house; perhaps thinking it would be there if she returned, perhaps thinking she would come and take it away some day. The Wagoneer stayed through more than a winter, and one day Hunter called me and barked, "Bring down some dynamite – a lot of it."

Well, I did that, and we sat in his kitchen drinking whiskey as he spilled out his need to eliminate the Wagoneer from his view and from his memory. There were fist poundings and many loud "Goddammits," and more whiskey.

Eventually it became time to act; there is some rationality required when mixing whiskey and dynamite. Hunter hauled a twenty five pound canister of gunpowder from the war room and we went to work. Seven sticks of dynamite were placed head to toe from mid-engine to the firewall, the gunpowder placed in the driver's seat. My fuse burns roughly ten seconds per inch, I jammed eighteen inches into the blasting cap and crimped it with my teeth.

My rule is "walk, don't run," and I made it down to the picnic table with about a minute of fuse left. I didn't look at my watch, the vagaries of fuse chemistry ensure that the explosion always comes as a complete surprise, which it did.

We were barely one hundred yards from the blast and the shock wave knocked the wind out of our lungs, yet we "yeehaaed!" hugged and clapped each on our backs. When haying that fall I found a fender that had sailed over our heads and three hundred yards further, almost to Woody Creek.

———•◦•———

The world, an entity out of everything, was created by neither gods nor men,
but was, is and will be eternally living fire, regularly becoming ignited
and regularly becoming extinguished.

HERACLITUS

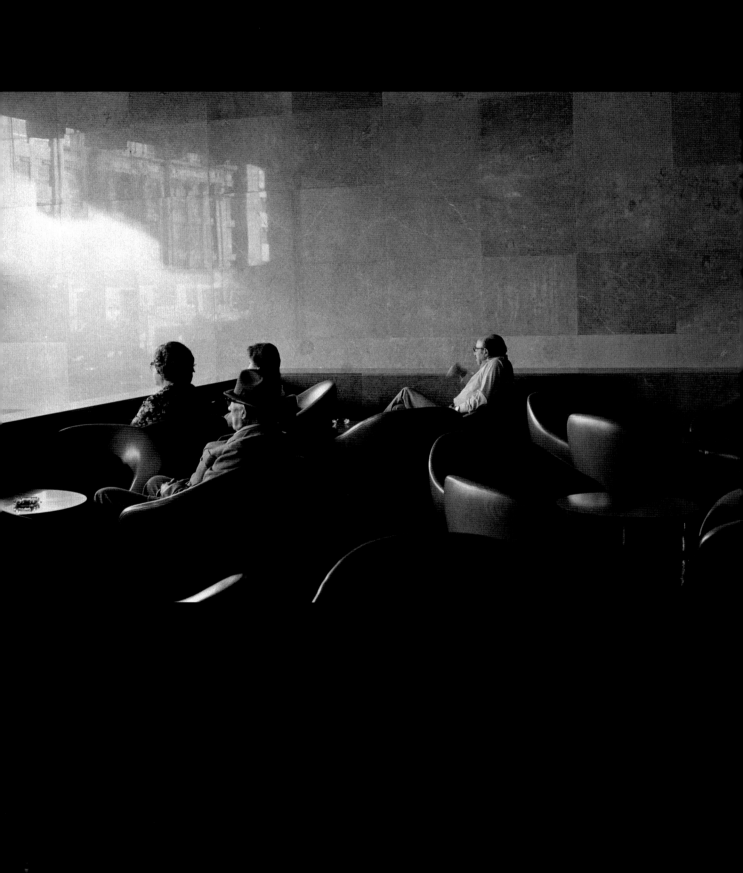

There's a balcony overlooking the street above the lobby of the Hotel Carrera in Santiago, Chile. These gents came in from the street – they were not of the hotel – and sat for several hours after breakfast time. I watched to see what they were doing, which was simply sitting and looking out the window at the street from where they had come. They did not talk to each other and I reckoned that they did not know each other. After an hour more they left, without a word, one by one.

It was the same every day and always men, no women. Time is perhaps all we really have to spend, and I wondered what was bought by coming together without communication to look out a window at a quite ordinary street scene. For a moment I floated above myself and observed my solitary self observing them watching.

———•◆•———

Nothing is so rewarding as a stubborn examination of the obvious.

OLIVER WENDELL HOLMES

2. MYTHS AND WOODY CREATURES

Woody Creatures, as Gaylord Guenin [formerly considered the Mayor of Woody Creek] has named us, love Woody Creek. We love the rural physical beauty of the place, the plethora of wildlife, the streams and mushrooms. And we know and love each other, that's why we hang out together so much and gossip.

Woody Creek is a myth and the Woody Creatures therefore become mythical, and we know it, indeed live it. Being myths is a chore, but we're up to it shamelessly and shamefully.

Though George gave up scientific academia in 1971, his colleagues warned that the scientist as the "skeptical enquirer" is like the "blood on Lady Macbeth's hands, it can never be washed off." And yet, in finding his home, George has learned to embrace the unknown, rather than dissect it. I would not say that George is a God-fearing man, nor that he cares much for religion or traditions. "Most of the time I'm comfortable with the idea that shit happens, the universe happens, enjoy it," he admits. "Most of the time."

It's no secret that not many scientists believe in God, heaven, hell, afterlife, reincarnation, astrology and other beliefs that can safely be labeled as magic and myths.

I can recall only two episodes of doubt that God does not exist. The first came with a terrific hot summer-day line squall sweeping across the Maumee River and towards my bedroom window. The storm was backlit from the west and its bottom was unusually dark, ominous and turbulent. As the storm grew closer the turbulence produced a dark finger that elongated downwards; and it was pointing at me. I may have muttered "Oh my God!" but what I meant was, "I have sinned and God has come, now, with his terrible swift sword."

The rain came, pelted the windows and the roof, and like summer Midwestern line storms, was past within thirty minutes. And I was still alive and went outside to walk on the wet earth, barefoot.

I theorize now that true believers, as opposed to the merely brainwashed, have such experiences of intense singularity.

*In his irreverent style, George built several structures on his Woody Creek property over a period of thirty years without attaining permits. Only until recently has he legitimized those structures so that when he is no longer around, his survivors are not burdened with bureaucratic nonsense. * Likewise, he carries very limited insurance.*

If one does believe that there is to be a judgment day then there is considerable freedom about being an outlaw, there being only temporal consequences.

Reflecting on our conversations and his compositions, I rummage for George's secrets, his locked closets. The most I can come up with so far is a handful of universal faults and frailties: inconsistency, hypocrisy, and irresponsibility accompanied by impish smiles that make one speculate: what's going on in there?; does he bury the sort of secrets that

would cause mere embarrassment or isolation? I suspect it is the former, but how can we ever know someone else better than we know ourselves? Should we expect our scientists, teachers and parents to be anything less than what we all are, even if they do stand before us as self-proclaimed experts or celebrities? It is human nature to beg for leaders, as much as most religious teachings warn that man should never worship other men or idols. Logically, then, a few of us must end up martyrs. Is this, then, the fear? Not that we will discover his secrets, but that we will make a martyr out of him — a caricature of a person who never existed?

In my sophomore year at the despised Hotchkiss school, I was sequestered, sent from my regular dorm room to the second floor of Main to be under the surveillance of "Fat Russ" Edwards. The punishment system at Hotchkiss was a censure for each individual failure. And a sequester for garnering three censures. My censures were all behavioral, not academic. I remember that one had been for pieing a comrade's bed. Fat Russ didn't love me, indeed he had flunked me in Latin my Freshman year and I was now repeating the course, destined to flunk again. My room was exactly across the hallway from his room. Part of sequestration was having to keep one's door open until lights out, and Fat Russ would stand in his door staring at me. I felt terribly alone and unloved. What parents could send a son to such a condition if they loved him?

I recall the following logic: God sent Jesus to earth to suffer and sacrifice his life for man's sins. Surely I was suffering at or above the level of Jesus, even as he was offered vinegar to drink on the cross. If Jesus was suffering, then suffering is Jesus. The only explanation for my degree of suffering must be that I myself was the second coming of Christ. This was some solace, but greater solace came when the punishment was finished and I returned to my regular room.

Speaking with George I get the feeling, however, that he has in fact believed in some kind of omniscient being more than just once or twice in his life. Perhaps that's just projection on my part, wanting to feel connected on some sort of cosmic level. But then, why all the questioning? Why all the pushing of false boundaries? Why all the creating and creations, documentations, proofs of his existence? As a theorist, he is perhaps searching for other translations of God outside of those found in Biblical parables.

What myth, you might legitimately ask, what, indeed is the myth of Woody Creek? Well, it is beautiful, sparsely populated, intensely inward looking, home of some public figures; but the myth, I think, is of purposeful irreverence, about saying it like it is and getting away with it, maybe even a brief one-handed clap of applause for ourselves and our mythical role in this strange Valley.

Or perhaps, he leverages his intellect to continue running from the authorities and his past, over-analytical biographers, and pretentious conversationalists.

It is important at events like cocktail parties to identify any absolute truth believers and treat them with care. It's not a good place to argue about the scientific method, even if they ask for it. In fact, if they do ask for it, it's a setup.

In any case, Woody Creek was and is the home of many eccentric creatures, with George Stranahan at the tail of the road. Eighteen years of ranching pulled George out of his head, and into the land. He found meaning in irrigating the land as such work revealed "purpose and necessity, more so than in physics."

These bottomlands and mesas of the Rockies now under assault by humans for recreation, lifestyle and homes were once a quite different ecology in a vastly different human economy. Standing on a mesa, now either an abandoned hayfield or one hayed for reasons other than profit from the hay, one can look up, first at the oaks, sage and mountain mahoganies of the fringes, further up to where aspens and cottonwoods transition into the spruces and fir that grow on up to the tree line. One can look downward through the oaks, sage and mountain mahoganies towards the wetlands and creek bottoms there are willows, chokecherry, serviceberry crowding next to the hayfields there. There were then, as now, seed eaters, berry eaters, squirrels, birds, a whole food chain from the herbivores on up to the predators and scavengers. Of course it's more a food triangle with a base of herbivores, for each level up wastes some 90% of the food value of the level below. But it was different then; it was their economy.

Standing in what was once an economically sensible hayfield I simply interpolate what once was from what I see above to what I see below. I doubt it's wrong. I close my eyes and see an oak savannah smattered with junipers, aspens and spruce; at my feet are holly grapes, thimble berries, boletus and grasses that I can't identify. I open my eyes and see smooth brome and orchard grasses imported from elsewhere by my local co-op, alfalfa deeply rooted but old and stalky, mule's ear, thistle and dandelion. I know these things for I have plowed these fields and drilled these seeds and fought these weeds. We call it agriculture, cultivation of the land.

His vision of the place remains, of transforming his "environmentally and economically sustainable Western ranchland into a setting of beauty, solitude, sensitivity to a long range vision of the changing larger world community" and one "that brings spiritual, cultural, and civic value to the local community." But it is only the marvelously wealthy who can reap the benefits of any substantial land ownership these days.

For the visitor, Woody Creek is the Woody Creek Tavern and the Woody Creek Store and Gallery, and most recently the Woody Creek Community Center, all entities that George established. It is margaritas at the end of a bike ride from Aspen, Limousin beef burgers and Flying Dog ale; it is exhibitions by artists who have made their mark on the unincorporated town, and a showroom for George Stranahan's photography. And for many, Woody Creek is also, in its mythical stature, a pilgrimage to discover its telltale creatures.

My main luxury in those years – a necessary luxury, in fact – was the ability to work in and out of my homebase fortress in Woody Creek. It was a very important psychic anchor for me, a crucial grounding point where I always knew I had love, friends, & good neighbors. It was like my personal Lighthouse that I could see from anywhere in the world – no matter where I was, or how weird & crazy it got, everything would be okay if I could just make it home. When I made that hairpin turn up the hill onto Woody Creek Road, I knew I was safe.

- Hunter S. Thompson, Fear and Loathing in America [2000]

*In November 2008, the month George turned seventy-seven, he and Patti moved into their new home at the top of the hill in River Valley Ranch, a recreational and residential development in Carbondale, Colorado, about 40 miles from Woody Creek. Their entire property of 245 acres in Woody Creek is listed for sale, with half of the land protected from development under conservation easements and only 60 acres available to development of just one home up to 10,750 square feet. Most of their friends in the valley live in Carbondale now, and life there is exceedingly more economical and manageable. The Gonzo bumper sticker pasted in the back of George's Prius has been replaced by an Obama '08 sticker, and George's two-minute work commute down a dirt road from his home to his barn has increased by three minutes or so, on paved roads and a two-lane highway to another barn located at the Flying Dog Ranch of Carbondale.

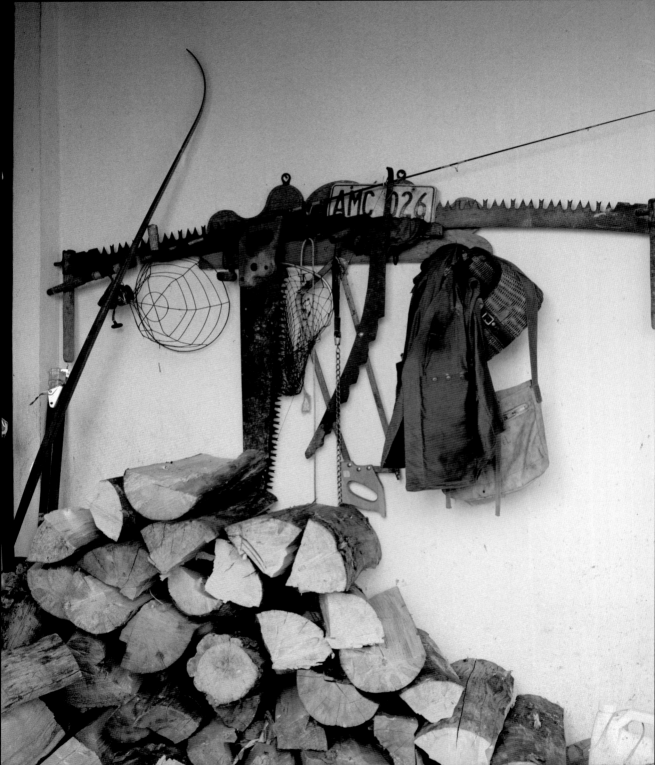

There's more to be learned from the study of a man's back door than of the front. The front is maintained for guests, the postman, the passersby, the Minister of the neighborhood Church of the Latter Day Saints, who calls, without much hope. The front is a sanitized invitation, a tidy representation of what we might be if we really got it together.

The back door? We know the people who use the back door, and they know us. There's no need for it to be either neat or presentable. The daughter's boyfriend brings in a few logs for the evening fire on his way up to her bedroom. Nobody, but nobody touches the master's fly rod, as ready to go fishing as a dog is for a walk. The back door is the digestive system of a home.

———◆•◆•◆———

I want a house that has got over all its troubles;
I don't want to spend the rest of my life bringing up a young and inexperienced house.

JEROME K. JEROME

To hang up one's hat: to quit, to be done with it — move on. But if you hung up your hat, and that hat still fits, can you then just pull it back on and step backwards in time — start again from where you were when you quit?

———•———

Gone is the fig, the oyster, the mango,
The red candle — its wick.

SUSAN HAHN

———•———

Then wear the gold hat, if that will move her;
If you can bounce high, bounce for her too.

F. SCOTT FITZGERALD

———•———

The chrysalis of my consciousness
bleeds and leaks into the dark edges
of memories I had yearned for
and polished slowly to the
luster of black pearl,

then put away into a box
lined with soft velvet.

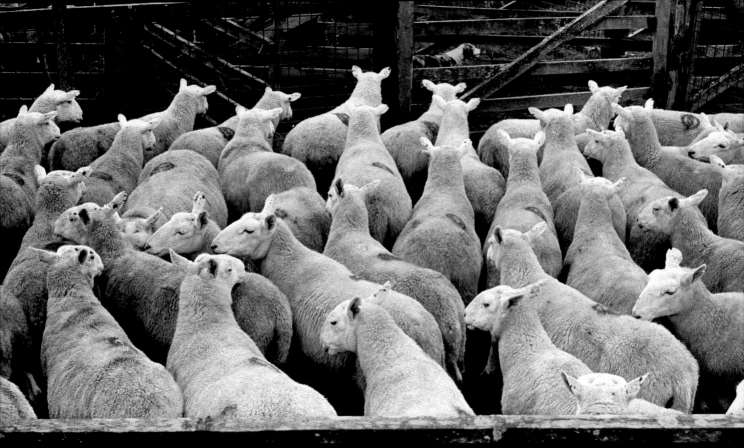

Angus and Fergus were brothers and stayed behind in the old country when their sister Celia left for Boston where there were a few relatives. The brothers kept to the old ways, tending sheep as the family had for generations. They used their own rams to breed their own ewes, and that economy netted considerable inbreeding. A grazed-out farm, weak stock, and the globalization of everything ensured their poverty. Whatever companionship they found at the pub was solely male; no woman would consider marriage into this situation and didn't tempt it.

One day Fergus said, "Angus, I don't want to die in this place."

"Where then?" replied Angus.

"Someplace where I don't feel poor."

"And where and when would that be?"

One day they took all of their sheep to market and pocketed enough quid to rent a suite at the St. James Hotel in Edinburgh; and enough yet to order and eat a fine meal with wine, not the dark ale of their pub. A walk around the square and then off to bed.

I cannot say the words of what happened then. Brothers are kin and I think that allows things to happen that we needn't know about.

They had not neglected to give their sheep dog to a neighbor's care.

—•◆•—

We cannot say what great peace
Rains on the wild river.

RUMI

The boy seemed all right until boarding school. He was removed from there and sent to Switzerland for electroshock therapy for his schizophrenia.

Well, the rich parents didn't know what to do with their son after he returned from Switzerland not really fixed at all. They brought him to this little cabin here in Woody Creek and visited for a few days each year. He loved water, and would come visit to splash in the creek by my house. We'd chat about the simple things: clouds, trees, the traffic in Woody Creek. He loved the dogs and the kids liked him.

The Waco ditch runs in front of the cabin. Often, driving by, I'd see his naked body, arms raised to heaven, in the ditch just the other side of the fence. Irrigation water has no fear of a naked body, and vice versa.

And then, in that cold, cold ditch water he slit his throat and the parents came and took his body away. It's just a half mile down from Hunter's house; as I pass by I remember and wonder.

———◆———

We are wisdom and healing, roasted meat and star Canopus.
We're ground and spilled wine soaking in.

RUMI

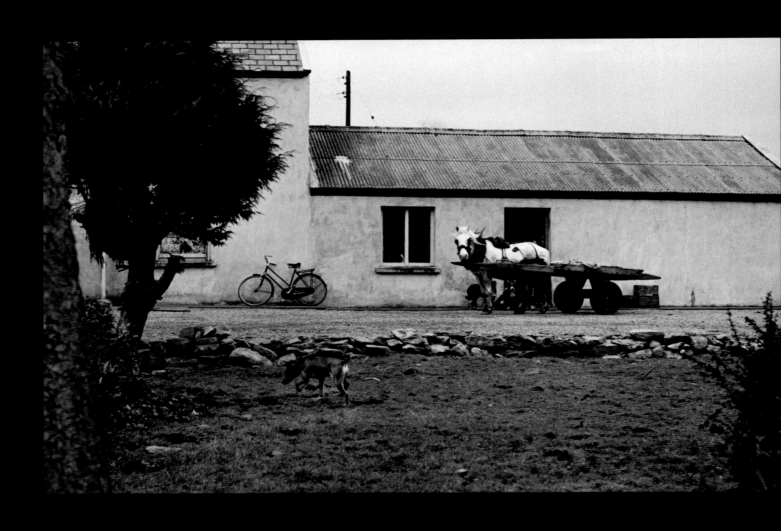

Ian had harnessed up his wagon, whistled up his dog, and driven over to his neighbor Jacob's dairy. Since he was going to town anyway, perhaps he could take Jacob's milk into market and save him the trip. Well, Jacob was suffering this morning from his angina and his daughter Dianna was just finishing milking the cows in the barn. Ian said he would wait until she was finished, and he sat next to her as she milked.

The smell of Dianna somehow overrode or blended into the smell of the barn and fresh milk in the bucket and Ian had memories of similar smells and of younger years. He moved his stool closer and told her, "I'll take the front teats, you do the rear." His shoulder touched hers and they milked together. Dianna flushed a bit, old men smelt so funny and there was so much she didn't yet understand.

———•·◆·•———

People know what they do; they frequently know why they do what they do;
but what they don't know is what what they do does.

Michel Foucault

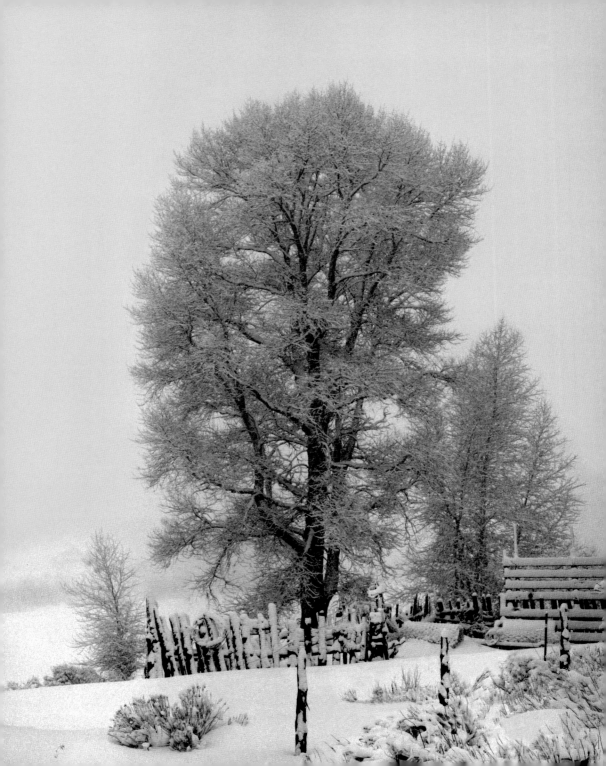

It's May now, and the leaves, pale green fingerlings, breathe for and halo the trees. If leaves can be said to live, then these will die before six months, for how can the trees make room for the crystalline coats and silvery trappings of winter to come without grief over their loss?

We're at roughly the fortieth degree of latitude; it's by choice and could have been any other number, either larger or smaller, with an entirely different outcome. To be more precise, the home is at latitude 39 degrees 15 minutes and 41.37 seconds North longitude 106 degrees 50 minutes and 31.62 seconds West which places me in Woody Creek at 7,867 feet above sea level. Other choices were then possible, but oh those extraordinary circumstances of a life, more than deliberation, did the work.

Good company can be found in Woody Creek, Hunter and Anita's place is just two doors (and two miles) down. This strong cottonwood marks the halfway point between our places. It is as graceful with snow as with leaves, and it gives comfort through the long winter. Hunter is not there, but I can as before navigate to and from Owl Farm by dead reckoning as well as dead drunk; ah, circumstances.

———•◆•———

Run to meet us on the road. We stay modest, and we bless.

Rumi

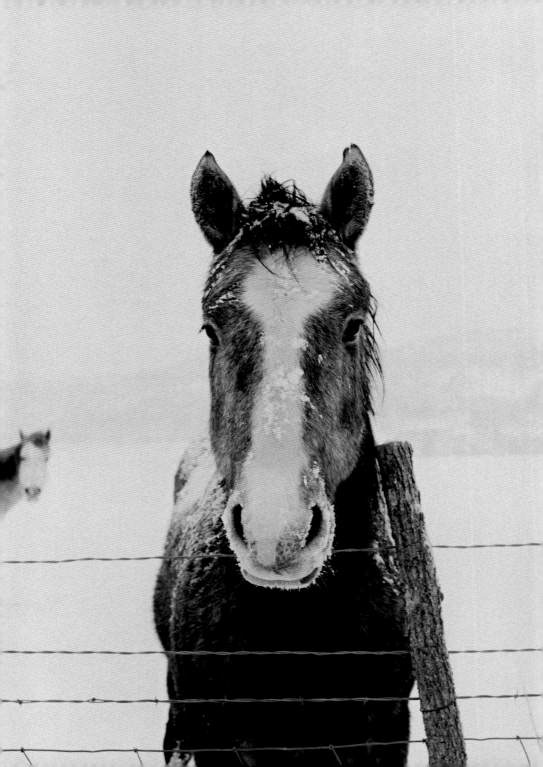

The registration papers gave his name as "Bengal Gold." I paid Wayne four hundred bucks for this horse he called Ben and two hundred for a well-used saddle. Another hundred went for Tony Lama shit-kickers. Ten grand to Strang for twenty-seven head of pregnant cows and I was a real, live cowboy.

As winter comes the cows moved from stubble grazing in the lower field into the pens for winter feeding and calving. Ben would not be ridden again until next spring when the cows would break fence to look for scarce and sparse early pasture and become, well, undisciplined.

Ben spent his own winter like this, waiting at the fence for his ration of hay and occasional handful of oats. I talked to him while he ate, "You're a good boy Ben," and more often just talking to myself out loud. I figured we were bonding; a horse and his lonely cowboy.

Spring came late, and when the neighbor called, "Get your goddamn cows outa my yard or I'll shoot 'em," it was time to saddle Ben up and go fetch 'em. With Ben's face in a bucket of oats I got the saddle on and swung myself into it. A startled Ben geared into full gallop straight for the fence. Pulling and jerking on the reins had the unanticipated effect of acceleration, not deceleration. As we came to the fence his sudden stop resulted in my equally sudden flight over the fence.

I sold the horse and saddle, kept the boots and learned to deal with the cows on my Bultaco Sherpa T.

———————•◆•———————

Be astonished, O ye heavens, at this, and be horribly afraid.

Jeremiah 2:12

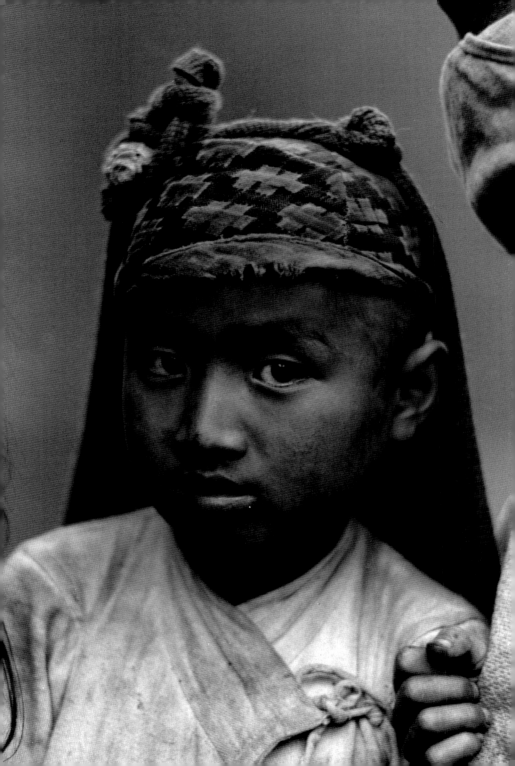

Survival of the fittest; we humans, we're the best at it. That means nurturing and defending our own children so that they too have their own children who have their own children … We speak of our "own" children with a sense of ownership, an ownership of their descendents too; it's "our" family lineage. And if my lineage's survival is threatened by the survival of your lineage … then there are things that must be done about that.

———•◦•———

Men grow tired of sleep, love, singing, and dancing sooner than of war.

HOMER

———•◦•———

When every child is our own child, then there will be no more war. For who can bomb the homes of their own child, and who can drive tanks through the villages of their own child, and who can send their own child to study war against their own child?

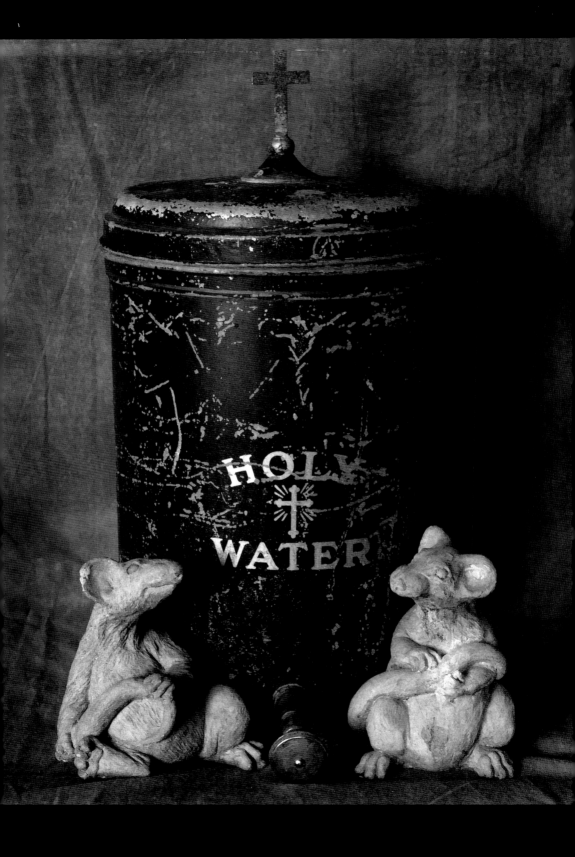

A thirteen-year-old novitiate is still a thirteen-year-old first. Angelina understood the choices she had made. She wanted to be here in the convent away from her home and the love that she knew there. She wanted to become wed to Christ in due time and live a full and reverent life in prayer. She envisioned her remains and the small headstone with "Sister Angelina Elisabeth" in the convent's cemetery. However she might imagine her future she remained a curious and restless thirteen.

As she explored the convent in order to make sense of the place and her own place in it she came upon Father Ramon's traveling canister of Holy Water. Half full it was too, for Holy Water is not thrown out just because it wasn't all used up last Sunday. Angelina put dabs on her forehead, cheeks and tongue and she felt, well, holy.

Sister Beneficence caught her in the act and put these rats there. "These are here to chew on your heart as your soul goes straight to Hell, which it surely will do if you ever touch this again." Sister told Father Ramon too, who refused Angelina communion for a month as punishment. Seeking forgiveness from a higher authority than Father Ramon she prayed until her knees were sore. She never knew if forgiveness was denied or if it had been sent and she just hadn't recognized it.

———◆◆◆———

My transgression is sealed up in a bag, and thou sewest up mine iniquity.

JOB 14:17

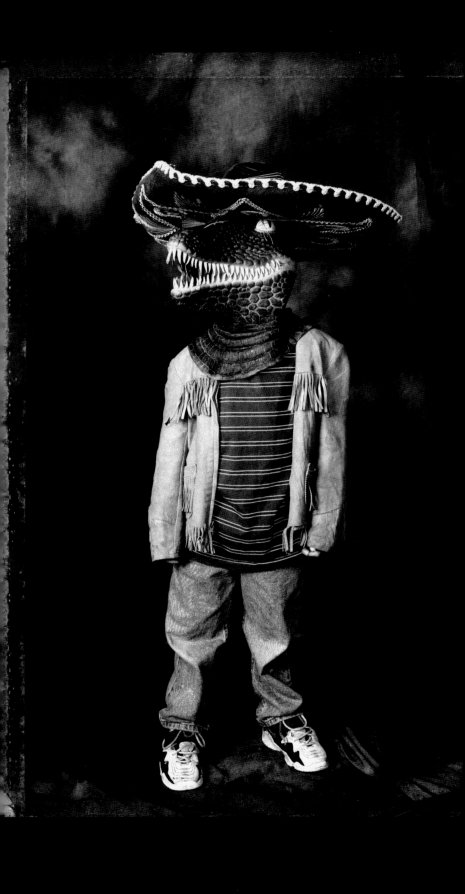

Once upon a time there was a little boy who had a wicked stepmother and a dad who, for reasons the little boy couldn't yet understand, did not take his side. It's quite common that a kid that gets picked on at home will get picked on in school too, and that was the case for this little boy.

He wept, he begged his dad and his teacher, he prayed to what he had been told was "a good God," all to no avail. Sometime in his fifth year, at about the same time that he lost faith in Santa Claus, he thought it through. Waiting for someone else to solve his problem was like waiting for Santa Claus; neither are ever going to really show up. His conclusion? "It's up to me to solve my own problems or else learn to live with them."

One Monday he put on the alligator mask and a big sombrero and went down to breakfast. The wicked stepmother began to pick on him and he growled and pounded the table with his fist; "There is some shit I will not eat" he said loudly and firmly. The wicked stepmother, surprised, became quiet and thoughtful.

The little boy wore the alligator mask and the big sombrero to school, and when some kids began to pick on him he growled and stomped his foot; "There is some shit I will not eat" he said loudly and firmly, and the kids became quiet and thoughtful.

It would be nice to say that he was happy ever after, but while there were days and weeks when he was not picked upon, a time would come when he would put back on the mask and sombrero, and everybody knew, without him saying it again, that there was some shit he would not eat.

<center>———•◦•———</center>

I hate this wretched willow soul of mine,
patiently enduring, plaited or twisted by other hands.

<center>KARIN BOYE</center>

Tim is a metal-worker, a sculptor really, and he kept his shop in my barn. In exchange for the space he shaped parts and welded the farm machinery. He could also rebuild old engines, which is what farm machinery is too often about.

He is a bachelor; oh, there have been some girl friends, but he drinks a lot. He is tall and has a big and frequent laugh; his dog Clyde, is a constant companion. One girlfriend was in it to reform him, which didn't work. Another just because her husband was out of town a lot. But hell, dogs, drink or girlfriends don't matter if you can weld the drawbar back on an old Hesston baler.

Some evenings he tells me, "I'm gonna get really drunk tonight," and I find his pickup (with the rebuilt engine) parked at the Tavern next morning. The bartender has called Tipsy Taxi and Tim remembered that Clyde too needed to get home and not spend the night alone in the pickup.

———•◆•———

Serve the wine that makes the heart like a mirror.

Rumi

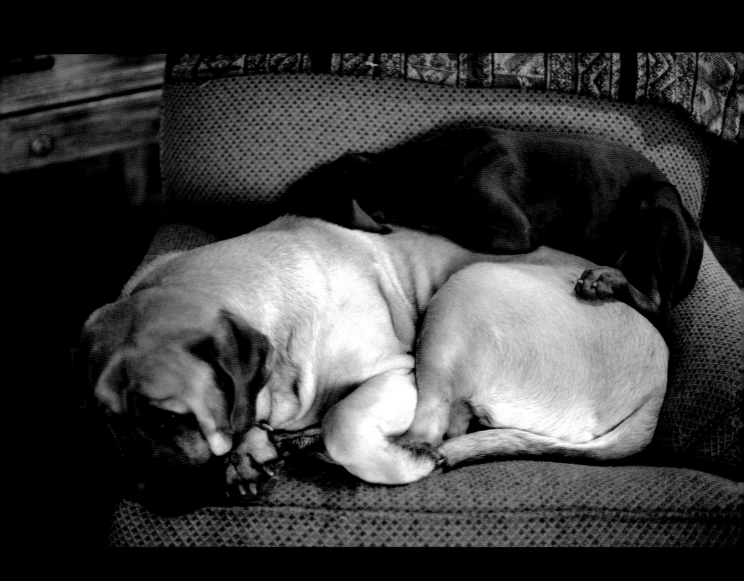

Kids need dawgs, there's a moral lesson in them, about empathy. Kids usually can feel empathy for non-human animals more easily than for their playmates or parents, but then these guys will bite if you torment them enough.

Flip, the Doberman on top, came to us just barely weaned and missing her momma big-time. Thumbelina, the English Mastiff, was a big bundle of soft and willing warmth. How would a big dumb Mastiff know what a baby Doberman needs? How would a baby Doberman communicate her needs to that big dumb Mastiff? Thumbelina owned the big chair — none of us wanted to dispute this — choose your battles, you know. Flip would hop up and the contentment appears to be mutual.

Thumbelina did not die until she had seen Flip full grown and more than sensible enough for a Doberman. Flip wailed like a banshee when we laid Thumbs down and owns the chair now herself alone. When she lies there I know she has memories.

———◦•◦———

You rock a sobbing child without wondering if today's world is passing you by,
because you know you hold tomorrow tightly in your arms.

NEAL MAXWELL

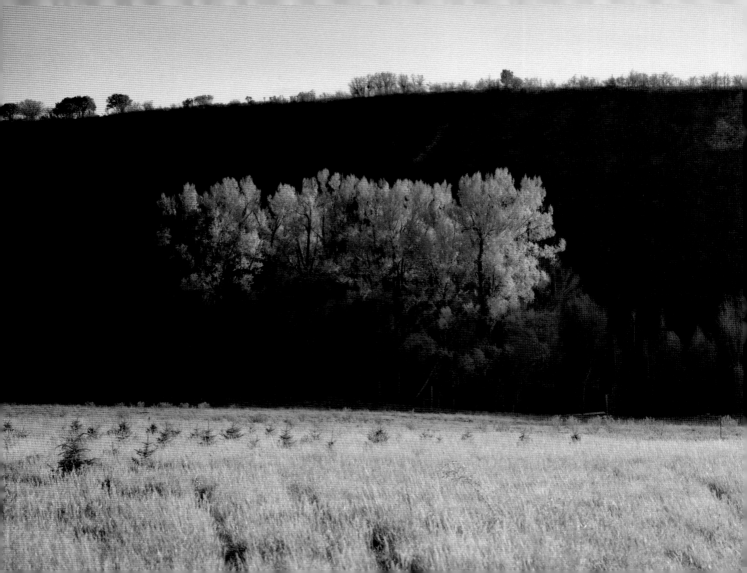

Fall in the mountains comes as a surprise and never announces how long she will be staying around. She's stunningly beautiful, and uncannily fickle, vanishing with the first serious cold front. The long winter of dark, cold and snow cannot be kept away and will stay through March. Winter has its own splendors, but life is lived as if underground.

As the fall sun moves lower in the sky there are many backlit moments like this. Halos appear where there were none before. These trees are across the street from Hunter's house; they're what he'd see today, if only...

Knowing that Hunter is gone is like facing an endless winter, cold and dark, and a part of me forever underground.

———•◆•———

We wished it all blank, bereft.
But no; the mists drifted on; something, one glint was left.
Next morning you had gone.

W.D. SNODGRASS

3. THE TRAIL OF COMPLEXITY

"What I'm trying to do is clarify the trail I've left behind. It's like an elephant leaves spoor, which is broken branches, little turds, trampled things, mudholes, and the spoor remains, but the elephant is eventually, you know … you don't care. It's gone," George says matter-of-factly. If there is a trail, then, it begins at one's childhood.

I don't guess that I'm "normal" in my feelings towards children; and who is? I suppose I wish that childhood could be something that in reality it never could be. Not a fairy princess story, not a wild child found and brought back, not the idiot savant or the 10 year old who wants to talk endlessly and wrongly about general relativity, black holes, or combinations and permutations. The nots come quicker than the whats.

So, the trailhead points to a Midwestern childhood, a first ten years spent in the Great Depression.

I lived in a decent house, didn't miss meals and went to a private school. So did everybody I knew. There were bums who came down Second Street in Perrysburg, Ohio. They knocked at our back door, asking for a plate of food which they got, and I always presumed at all the other homes along Second Street. Sometimes, there were gypsies in horse-drawn wagons on the street, or tinkers. Toledo was the gypsy capital of the U.S.

I don't want to talk about my own childhood, just to let you know that I think about it in relation to what I do these days. There's a bitter taste remembering the disappointments, some anger about the waste of time, some holiness around the forgiveness, and some acceptance about these feelings as well as that childhood. It was what it was. We all did the best that we could under the circumstances.

Acceptance is not denial of those feelings of bitterness, anger, holiness and forgiveness, it's embracing them as a whole, a coat of many colors.

These days you will hear this phrase often from George: Pilgrim Elder, but it is much easier to see the Emancipated Child. He has written that his being around children quite a bit is "a choice, not a hair shirt, not an attempt for redemption, but more a search for lost innocence," something he "lost long ago." He writes that he does not "want to be a child again" since he "didn't much like it the first time."

George is an early riser with every day presenting its own agenda. He drives a black Toyota Prius, even on the snowiest mornings since, statistically, more accidents occur in SUVs: it's easier to dodge a potential hazard when you're smaller. (Seven months after this statistical statement, however, George and his Prius collided with a truck in Woody Creek. It took months for the Toyota dealership to fix the car, during which time George drove a Ford Focus.) He is a slight man whose step is labored by past motorcycle and skiing accidents, and so he receives physical therapy weekly. "Between Medicare and a high-deductible health plan, I've screwed the world pretty good," he says in partial jest.

George likes to drop in and chat, and for others to drop in and chat, and he carries a cell phone primarily to answer it,

not to call out. He is a complex man, for sure, the way a child is complex: many moving parts seeking cohesion, always testing for "justice" and repulsed by an authoritarian's demand that you should eradicate the word from your personal lexicon; the kind of complex that makes adulthood, and adults, seem like the simpletons — narrow and perfunctory, set.

People continually expand their capabilities to understand complexity, clarify vision and improve mental models by engaging in different tasks, acquiring different kinds of expertise, experiencing and expressing different forms of leadership, confronting uncomfortable organizational truths, and searching together for shared solutions.

I know how sensitive scientists are to laypeople's anthropomorphizing natural systems — like thinking the attraction between atoms ("electromagnetic force") and between humans ("love") is somehow inter-related, but thankfully scientists do acknowledge a relationship between the scientific and the literate definitions of complexity — or rather, a relationship between our structural and spiritual lives.

There is a growing body of science about complexity, most of the work originates from the Santa Fe Institute, and the work has gotten far enough that books popularizing the subject are appearing, none of which I can recommend with any fervor.

Interestingly enough, the mathematics was developed by workers simultaneously working in the physics of spin glasses, the immune system, the origins of life on earth, the emergence and disappearance of cultures, and economics. The mathematics of each field showed great commonalty of structure and language with the others; at some early point it became obvious that each was talking, in some sense, about the same thing, and that analogy between physical structures and human events can indeed be made with some rigor.

For example, the connection between George and complexity itself.

Complexity is often said to be at the edge of chaos; disordered for sure, but not chaotic … Emergent phenomena, new collective behaviors, appear that could not have been predicted from an examination of the parts which comprise the whole of the organization. These emergent behaviors are usually central to the organization's capacity to adapt, learn, and evolve. Another characteristic of complexity is that no one simple perspective will suffice to describe it.

Examining the parts that make up George Stranahan's whole could not have been predicted. Indeed, the parts that make up the Stranahan family story could not have been predicted, and yet it is a story that is at the heart of American history and the automotive era.

George's grandfather, Frank Stranahan, and his great-uncle, Robert Stranahan, founded the Champion Spark Plug Company in 1908 which, until 1961, was the Ford Auto Company's sole supplier of spark plugs. George's father, Duane Stranahan, who was Frank's only child, and his mother, Virginia Secor (nicknamed "Did") had six children — four boys and

two girls (Duane Jr., George, Stephen, Michael, Mary Celeste,Virginia). George also gave his name to six children — also four boys and two girls (Molly, Patrick, Mark, Stuart, Brie, Ben) and unofficially adopted three other children (Felicia, Arleigh, Juliana).

Sometimes my own children tell me a remembered story from their youth, and yes it is from a different perspective than I remember it (if I remember it at all!), but there's something else. Often I remember the story and then I remember that what to me was another story, another place and time, has crept into their story and become part of that story. And this is what I think that tells me about the phenomenon of memories.

We each have many shards of broken stories that make up our memory, and we take these shards and build a mosaic out of them that is the story as we tell it now. It is not just one memory into one story, but many fragments of memories rewoven into a larger and more meaningful story. I think that our reconstruction of fragments of stories into a remembered story is a better representation of what happened (not factually what happened but what happened to that person's soul) than any video camera or lie detector could have produced.

There are many memories, accompanied by such specific smells, that come back with the cooking of venison. They are about hunters, my father and my uncles, their friends and whiskey; about cabins, woods and the smell of smoke: the smell of gunpowder, the smell of the dead animal and warm blood on the ground. As a child I was allowed to clean the guns at the end of a day's hunt, swabbing down the barrels with Hoppe's Number 9, a nitro solvent. No sweeter perfume do I know for bringing back floods of memories than Hoppe's Number 9.

Hunting was getting up before dawn, eating a breakfast of hotcakes and sausage, and being with my father, who said little to me directly. He did, however, seem proud whenever I made a good shot, for he himself was an excellent shot. I remember, with total recall, a fast and low flying green winged teal shot overhead with a single .410 shell that amazed him and myself. He clapped me on my shoulder and bragged that night to his friends. Never, ever, had my life seemed more filled with possibilities.

According to George, his parents — whom he called by name — did not spend much time at home and hired help mostly raised him and his siblings, but they attended to community matters with a passion. On the heels of the Champion Spark Plug Company's leadership in corporate accountability and philanthropy, Duane and Did established the Needmor Fund in 1956 in Toledo, Ohio with a mission to "work with others to bring about social justice. The Needmor Fund supports people who work together to change the social, economic, or political conditions which bar their access to participation in a democratic society." George and many other relatives, including his wife Patti, participate as Board and Committee members of the Fund.

Of course I had been to the drug store and to Grandma and Grandpa's, but these were novelties, not the

norm. Thus, I knew my way around in a universe wherein I called my mother Did, my father Duane, the yardman Clarence, the cook May, and the person who mothered me Miss Joss. I know that I heard her spoken of with a first name, but I forget, because to me, Did, Duane, Clarence and May she was universally called Miss Joss. A spinster for sure, and a Registered Nurse, which seemed very important to Did. Because this was my universe it was the norm and therefore unremarkable. What it was in my life, and therefore what I accepted with very little question.

It seems necessary to me now that this memory is preverbal, say something around 18 to 20 months: I am standing in my crib, hands on the top of that railing/guard that adults can move up or down and I can't, looking down first. Gigantic black and white squares of linoleum flooring, a huge number of them; as they begin to look smaller across the room I see my brothers crib and assume it is identical to mine and that he is asleep. There is a window above his crib as there is behind me. To my left the squares look more like diamonds and point to three narrow steps leading through a door. Three steps I think. The door to Miss Joss' room.

I remember Miss Joss' room; a wide hallway with her bed on the left, and then down the main stairs to the ground floor ending just in front of the front door of 422 2nd Street. Straight down the stairs and out the front door; straight down the stairs, right, and into the living room; one window towards the front yard and two windows towards the side. Not a yard, but the driveway back to the garage and the sole space that separated us from the neighbors on the East who I do not remember. Straight down the stairs and to the left into the dining room, left again into the pantry and straight ahead into the kitchen. The crib, the room with the black squares, and the kitchen were my home. All were on the west side of the house and were full of sunshine. Miss Joss was my caretaker. She put me into my Dr. Dentons, I suppose but don't remember washed my butt, fed me my Pablum, I liked the Pablum, I liked being fed, I liked the Dr. Dentons because they had slippers built into those durable sleepers. Slippers with some froggy little buttons on the toes. This memory must be from winter for that's when we wore the Dr. Dentons.

There was another turn at the bottom of the stairs, a left 180. A few paces to the stairs to the basement and straight ahead into my genetic parents' room. Just beyond the door a coal fired fireplace, their bed to the left and an entrance straight ahead to the backyard. Another place that I knew well.

Miss Joss did what mothers do for infants because my mother was busy doing what I didn't know and it didn't matter because this is the way it was.

One question I did have: if my older brother was having a "bad night" he got to crawl into Miss Joss's bed. I tried that once or twice, having a bad night, and was told to shush and go to sleep. My question was, why couldn't I crawl into Miss Joss's bed too? Youthful questions often go directly to deep truths; why was I being mothered by a person who would hold my older brother but not me?

At the time it was simply reality; have a bad night and be told to shush. Now that I think more about it I

understand that a nurse cannot afford to fall in love with a patient, a paid mother not to fall in love with the child. They are not yours to love, but yours to tend. And then you move on, with little regret, pain or grief of loss. Miss Joss lasted a long time but my older brother was the only one she held and I think she knew her mistake of attachment.

How necessary is it really to go back and examine the beginning to understand the journey? An age-old question and debate among historians and psychologists. Physicists believe that only by understanding the very, very, very beginning of the universe — as of now they have evidence to detect the universe only after the first trillionth of a second — can we make any headway in legitimizing our existence. But since George's first (hazy) memory is admittedly somewhere between 18 to 20 months old (approximately 50 million seconds), then how can we possibly hope to clarify this trail of complexity?

It is likely an evolutionary advantage to forget almost everything that has ever happened to us, for surely we do.

It's a long chain of reasoning, and that's probably the ultimate source of the problem; by the time we get to the end of that chain we've forgotten why we even started. We're left at the end of a chain that has no remembered beginning; disoriented.

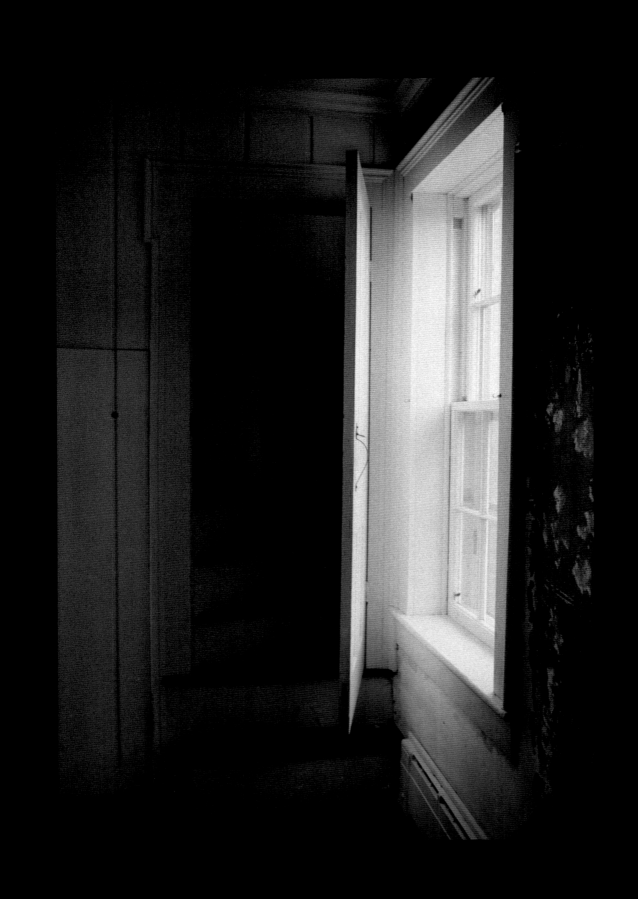

These are the back stairs, a few steps from the back door, and they go up to the hallway and to the back bedroom. That's where she slept all of her life after the crib in her parent's room. When she was eighteen she read Emily Dickenson and began her fantasy, that she was E.D. reincarnate. She became reclusive to her room, wrote exquisitely romantic poems that were sailed out through her window to the ground below.

Several young men around her age became cult readers of her poems; they composed their own superstitions about the mystery poetess; her femaleness was poetically evident. One in particular entered a rapture and late in the night opened the back door and started up the stairs expecting to meet half way on the way down towards him. She was not on the steps so he proceeded into her room.

Both torn bodies were found the next day. Nobody knows how it started or what exactly happened, but those of such a mind constructed their plausible story* and it stuck. It has been ever since a haunted house, haunted by their ghosts. And why not fairies instead of ghosts?

———•◦•———

Dying is a wild night and a new road.

EMILY DICKENSON

———•◦•———

*The police report read: there was virgin blood, the dogs went crazy with a shark-like frenzy and tore them apart. No, there were no dogs. Yes there was virgin blood, and then it became consensual, they took turns at each other.

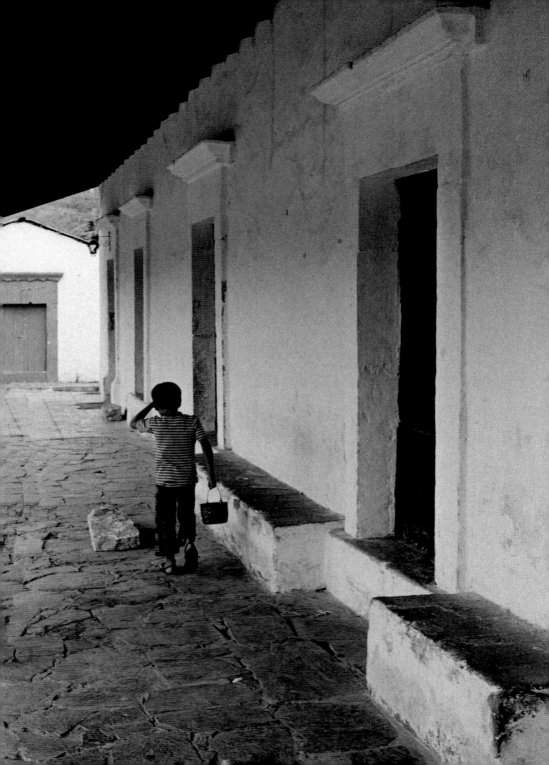

The end of a long and solitary day. Finding a half dozen turtle eggs, usually a matter of triumph, had been unable to lift his dark mood. He had thought many thoughts throughout the day, and now he was pretty sure he had it right. Now he was not so much mad as sad.

Two days ago he had found a puppy on his way home from school. He knew the neighborhood well enough to know that it didn't belong here; it was thoroughly lost. He took it home and asked his dad if he could keep it.

His dad said, "Put the dog down on the ground." And he did. With one sudden stroke of his irrigating shovel his dad severed the head, which rolled surprisingly far from the body. "There's your answer."

Over this day, sad about the puppy and mad at his dad had turned slowly into sad about the puppy and a great weight around his heart, which he would later understand as his first awareness of the human predicament.

———— ◆ ————

Beyond a certain pitch of suffering, men are overcome
by a kind of ghostly indifference.

Victor Hugo

Georgie Porgie, Puddin' and Pie,
Kissed the girls and made them cry,
When the boys came out to play
Georgie Porgie ran away.

If you've been named after your Uncle George and you hear this from your male classmates you know you don't belong. When you hear it from the girls, you know you're not even liked. My uncle had early immunized himself by copping the nickname Mose. I found no luck with anyone caring enough to grant me such relief. No teacher intervened against the taunting, and I retreated into myself and could not imagine any action on my part that would not make it worse. Slog on, someday I would be as old as Uncle Mose and have a big hearty laugh just like his.

School remained punishment until fifth grade. That particular teacher's care, concern and connection with the students was so great and inclusive that everything became different. I have no reason to doubt that my earlier teachers had care and concern for me, but it was connection that made all the difference.

———◆———

The reward of teaching is knowing that your life makes a difference.
WILLIAM AYERS

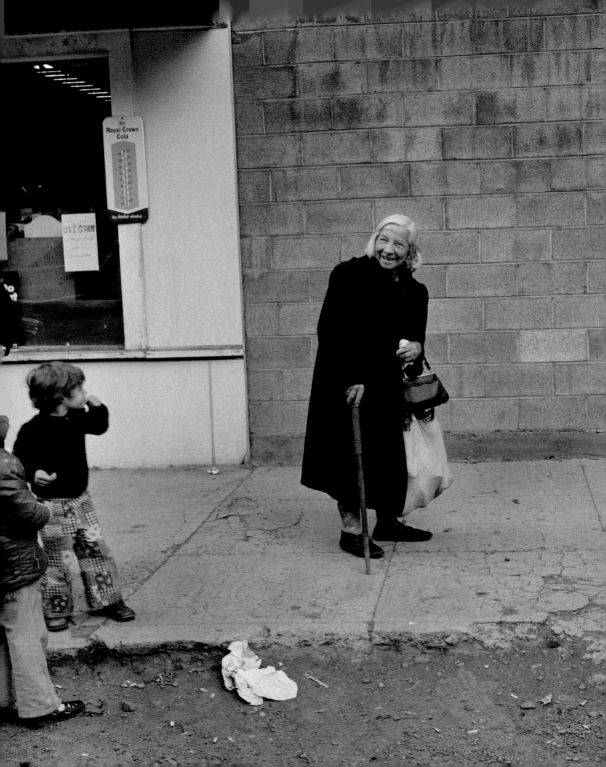

She lives alone now, just a little way out of town. Most days she walks into town to buy a little of this or that and to chat with older shopkeepers. Her son was a bachelor and a cop. After he was shot a portion of his pension came her way, and with social security she got by quite comfortably. She misses her son, for he had lived with her and given her sweet company after her husband died that long year when the windows rattled from the North wind.

She likes talking to these kids that remind her of her son in youth. She doesn't ask there names or how old they are, instead it's, "How are you, my son? I haven't seen you before, are you visiting? If you like catching snakes I can show you some not far from here."

Her son was shot breaking up a wild bar fight at the Sheridan, with his own gun grabbed from his hand. During their evenings after the news hour he had often talked about being a cop. "I've seen it all," he would say, "drunks, whores, wife beaters, smack addicts, runaways, derelicts, and the rich guy offering a C note to beat a speeding ticket. I'm the garbage man for the human species."

"Why do you keep doing it?" she would ask, "You could get a decent job."

"Mom, I'm a shepherd too. Somehow we've got to get all of the sheep, easy sheep and hard sheep, into the pen at night, safe, asleep, and looking for a new dawn, a better day. I'm a hope dealer."

—•◆•—

Hope is nothing else but an inconstant joy, arising from an image of something future or past, whose outcome to some extent we doubt.

SPINOZA

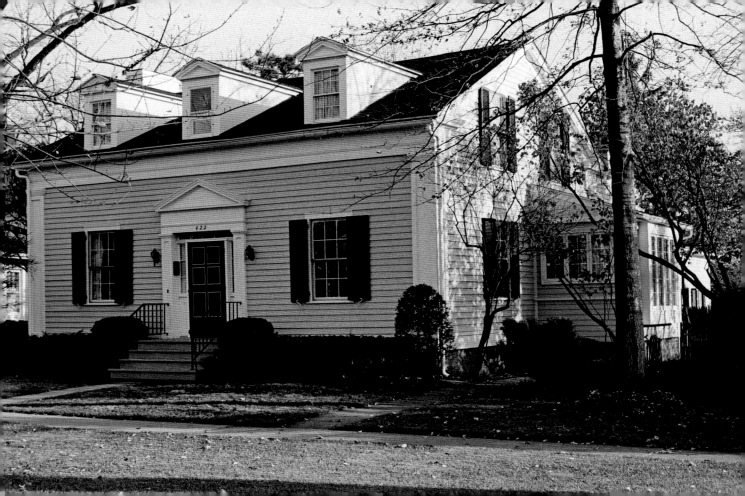

Bundled home from the hospital to 422 East Second Street, and there for ten years more. Surely I went in and out of that front door many times, but I remember only the back door, the door into the kitchen. The garage was on the alley with its springtime glories of rhubarb, from there through the white gate, across the backyard with its comforting sandbox, up three steps and into the kitchen, this I do remember.

Some safety I found in the sandbox, or going through the kitchen, the pantry, dining room and then up the stairs that ascended just feet from the forgotten front door. My room was the top right window in this picture.

Up the stairs quietly for they lay next to the living room where I could hear Mrs. Duke, Aunt Olive or the loud Clare Hoffman. I didn't know how to "be" with my parents, and was even more uncertain with their guests.

———◆———

Only in a house where one has learnt to be lonely does one have this solicitude for things. One's relation to them, the daily seeing or touching, begins to become love, and to lay one open to pain.

Elizabeth Bowen

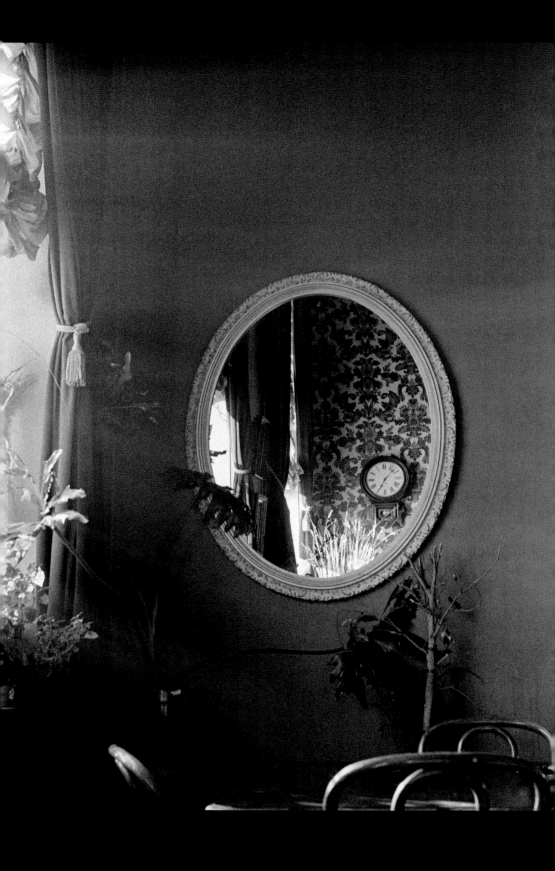

It's early in the afternoon at the J-Bar. I am alone and drinking beer, and I like being alone and drinking beer. It suits my mood right now as I sort out some of the events of my past. Sorting out? Brooding about more likely. The mirror helps; I can look into it and see little movie scenes. I can blink and make them stop where I want them to, but then they play on in the bubbles of my beer.

I ask myself if I want another beer, and wonder why I bother to ask. Suppose I don't agree with the answer? Appeal…

———•◦•———

The pungency of loneliness clings thicker than stale beer and more rancid than barroom flirtations.

Charles Levendosky

Amy had her wedding on our front lawn; it was one of those faultless August days in Woody Creek, and she looked lovely and in love. A short ceremony in warm sun and then the party begins. The dinner was catered and Frank played keyboard with his little band; they danced, we all danced, and the evening brought its coolness with the dusk.

With judgment quite impaired I fetched my tenor saxophone from its case and insinuated a B flat into Frank's jazz riff. As Frank has a good ear and understands drinkers he changed keys and I leaned into it. They didn't stop dancing, so we played on, and after a while we nodded and smiled and I put the sax away.

Next morning the details can be easily read in the detritus of the evening: a wine stained tablecloth, a shoe under the rose bush, a boutonniere floating in the pool. Yesterday carefree joy, hope and promise; and today we have the rest of it, the mess to clean up.

———◆·◆·◆———

If you drink, go swaying to the land of secrets.
If you're already drunk, then come as you are.

Rumi

For their eighth grade graduation picture I ask each kid to "Show me who you really are." Looking at this Tanea said, "Yes, this is me." The sitting is over.

If I asked myself "What is me?" I would describe a me inside this skin with sounds, sights, smells, words, thoughts and feelings swirling uncontrolled it seems, looking out at what is almost easier to comprehend, refrigerators, dogs, and of course, you Tanea. And you, I dare presume, would do the same. Isn't it astounding that what is outside of us can be seen more clearly than what is inside and yet we agree that this Polaroid is indeed you.

———•—•—•———

*In order to understand, it is immensely important for the person who understands
to be located outside the object of his or her creative understanding in time, in
space, in culture. For one cannot even really see one's own exterior and comprehend
it as a whole, and no mirrors or photographs can help; our real exterior can be seen
and understood only by other people, because they are located outside us in space,
and because they are others.*

MIKHAIL BAKHTIN

———•—•—•———

Is this nonsense an unintended consequence of our need to explain ourselves?

Bill had a mom when he came to the Community School, but he didn't have a dad and couldn't remember ever having a dad. His conception of an adult male was someone dating his mom, taking her away from him, to dinner, movies and up to the bedroom. He was suspicious about the intent of every adult male and this applied to his first grade teacher too.

Steve, like most every first grade teacher, was at the competent amateur level of shrink, and just for Bill he devised the Flower Shop. Cooperating parents would drop off flowers, potted and cut, along with their child. Bill organized and ran the Shop where these same parents bought the flowers with poker chips that Steve freely provided. Accounting, advertising and inventory became Bill's curriculum and he happily allowed Steve to help.

———◆•◆•◆———

We are here to help each other get through this thing, whatever it is.

KURT VONNEGUT

Angelina loved being a kindergarten teacher. Of course she loved her students and they loved her back. But she also loved their play and innocence, even when they were merciless and cruel towards each other. She found it difficult to relate these things to her love of God, who did not play, was not cruel and was infinite mercy.

The children were very immediate; this morning she would be with them within the hour. She thought carefully about this one in particular. Her name was Elizabeth, her parents called her Liz, and the kids had lisped this to Wiz, and then it blossomed into Wizard.

Wizard enjoyed her new name and would pretend to juggle or just wave her arm as if it were a magic wand as her friends would chant and clap, "Wizard, Wizard, Wizard."

Angelina had wept alongside of Wizard's parents in Mother Superior's office as it became known that there was a doctor's diagnoses and prognosis. Maybe three years. Mother Superior said, "It is God's will that she join Him before she finds sin," and sternly shed no tears.

—◆◆◆—

While darkness thickened the white walls
And shadows crept like a judgment across the floor.

EDWARD HIRSCH

Angelina substituted in Sister Dolores' kindergarten class while Sister went on retreat at Noroton on the Sound. Angelina didn't think they needed more catechism, Dolores was very thorough there. She thought instead of a day of fantasy rather than study. She allowed her students to bring in props or costumes of their choice to express who they thought they were now or what they imagined they might become. A photographer took a Polaroid picture and the photos were placed carefully on the classroom door. The kids giggled and chattered as they looked at each other's fantasies.

The photos were still up when Sister returned. She was alarmed enough to call Monsignor, who too was concerned with allowing young people such freedom of imagination. Angelina took the ensuing reprimand seriously, did her Hail Marys, and prayed that night to be delivered from the evil of her own imagination.

—◆◆◆—

Suffer little children to come unto me, and forbid them not; for of such is the kingdom of God.

LUKE 18:6

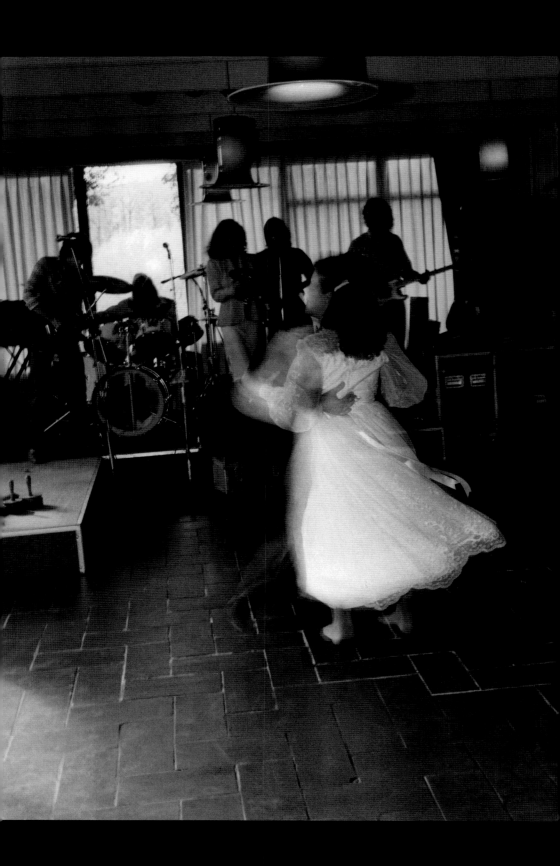

It was a flawless summer afternoon when Princess Tammie and Prince Patrick stood before me on the patio to speak their marriage vows. "Fine as fur on a frog," I whispered to the Princess before we began, and 'twas the truth. The ceremony they had written was short and soon we went indoors to party and dance. Oh how they danced and oh how happy they were and we too, all of us.

They joined our 1983 March of the Innocents, a Savage Journey into the Heart of the Himalayas. The ambitious plan was to go first to Concordia and base camp K2 in Pakistan, then to Gangotri and the Gomukh (mouth of the Ganges) below Shiva Ling, and finally to the Everest region and over the Cho La pass to climb Gokyo Ri.

We were entirely innocent of the knowledge, skills and experiences necessary for this March. Reinhold Messner has climbed all of the 8,000 meter peaks without oxygen and has said of the Braldu Gorge, on the route to K2, that it was the most dangerous thing he had ever done. It went well for us, luck of the greenhorn.

When we got to the Gomukh Tammie grew listless and complained of diffuse disorders that I could not identify as anything treatable from our extensive medical kit. When we got back to New Delhi she went to the hospital for diagnosis. They said simply, "Get her back to the U.S. as quickly as possible." The rest of us went on to Everest and returned home to a Tammie with run-away melanoma eating her brain, liver and lungs. At age twenty-six she struggled finding her own meaning in dying.

———◆———

I will build an altar from the broken fragments of my heart.

YEHUDA HECHASID

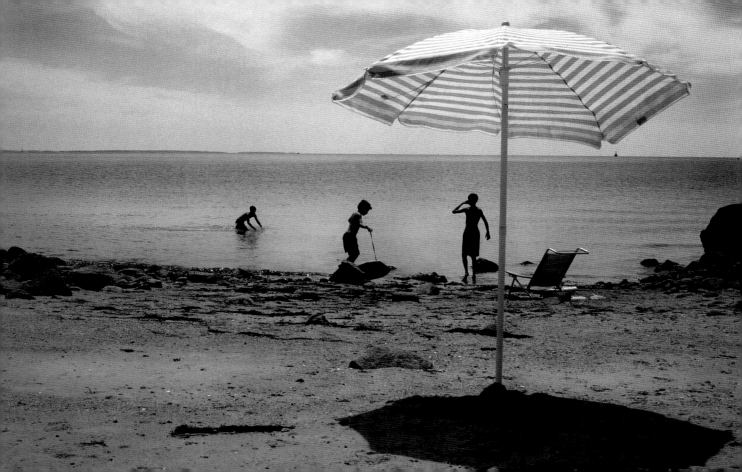

Sometime before age ten I asked my mother if I could go down the block to the service at the Grace Evangelical Church. She said, "Suit yourself." When I came back I proudly showed her my handful of quarters, explaining that they passed them out in a little basket and that I thought I had taken only my fair share. "Shame on you," she said and I was made to walk back, knock on the Deacon's door and return the money. It didn't make sense; I felt innocent along with the intensely painful shame.

———•◦•———

Shame is an essential element in the civilizing process. It is the price we pay for our triumphs over our nature.

Neil Postman

———•◦•———

Adults do the grown-up things that put food on the table and babies in the bassinet. Yes, we lose our innocence, and watching the sea sprites innocently frolic returns a bit of it to me.

4. DISCRETE MAIL

The brain is not a post office with little slots holding discrete mail for separate deliveries.

In the folder of personal letters that George has shared with me, the majority of correspondences are either from Hunter S. Thompson or Cynthia Oliver, also known as "Ed" or "Eddie."

For a couple of years Eddie hung out with Doug, Jules, Kevin, Beth, Spunk and Wronsky, as did my oldest son Patrick. Eddie was a cigarette smoker and I suspected, with no particular evidence, that she was easy. If she didn't talk much, at least she was truthful.

Eddie and Doug left town as soon as their school year ended and ended up hanging around my place in Woody Creek. I was in single dadship with the boys while the divorce proceeded. Blatz turned into Millers, and the rules were about the same: Take a beer and don't be a jerk. The bad shit hadn't come upon Eddie yet, at least as far as we could tell. It was not sweet going through the divorce, losing the children (and some genuine cash), but sweet enough gathering a new life and having some kids around, dependents sometimes and sometimes not, on that cusp of being 18.

Eddie went home after the summer, a job as I recall, and I didn't see her for several years. The next time I saw her I was sitting on the downstairs pot with the door open, thinking I was alone in the house, when I heard step sounds coming down the stairs, scaring me good, and then a fat face showed that I recognized in spite of the fat. It was Eddie. I explained that I was living alone and that she would have to leave, go to some of her family, anything, and I would buy a bus ticket to wherever that was. I stopped at the traffic light by the airport liquor store and she was gone. We write now, from time to time.

July 21, 2000

Dear George + Patty,

Hi, I'm feeling better but still having bouts with my voices ... I don't remember any of last year; Jim + Krista's wedding, Christmas and the year 2000. From January to the end of May. Nothing.

But whatever it was that happened, it had to. Suppose to. I'm happy with my new home. But want to live in Boulder Colorado. I have to wait till [my doctor] agrees with me that I'm better - enough to make a move. I think I'll talk to my case-worker, see if she can find me a case-worker in Boulder.

Never did like the east.

Oh yea, [My doctor] has spaced out the ECTs to once every 2 wks or twice a month. The reason I'm doing ECTs is because we couldn't get a Med to work. That's what they told me, my case-worker. But I also know that I assaulted my Mother and I guess Dad called the police. Involuntarily hospitalized. I don't remember going down to Ann Arbor. I'm not going to ask either. I don't want to know. What I did.

...I sometimes think I'm talking to John Lennon. I wonder if there is a heaven? I suppose it's all part of my paranoid schizophrenia. I'm a Dreamer ... I'm gonna get this in todays mail. It's about 11:00 AM time. Hope all is alright at Woody Creek. Just felt like writing. Been writing a lot. That's all there is to do.

Love,
Cynthia O.

P.S. Is Hunter Thompson still down the road?

We all knew Hunter Thompson because he was our neighbor during our summers in Woody Creek. Hunter stopped by when he was on his way East to cover the 1972 presidential election. We drank and did speed. I almost missed a class through oversleeping.

Betsy squeezed enormous volumes of grapefruit juice because that was Hunter's hangover cure. We talked late into the night, certainly about politics, the evilness of Nixon as well as his humanity, but also about alienation from society, the barricades in Chicago 1968, and youth today.

I loved to talk politics with him; the boy-children worshipped him for the same reason that students today worship him – he gets away with a lot. I confess also to a fascination, envy even, of Hunter's outlaw behaviors.

Hunter, in a draft dated January 25, 1971, describes the visit this way: "Then I went out to East Lansing, Michigan for a long chat with the NRA president, and after that quickly out to a home near the MSU campus for a chemically-adled night with a friend whose living room floor rolled back to unveil a big swimming pool. We spent part of that night pondering the horrors of his situation: a full professor at Michigan State with two teen-age sons who kept using the house as a refuge for runaway junkies. Here was a wealthy professor/liberal with enough blue-chip economic clout to buy & sell the (local lawyer) president of the NRA, but who found himself constantly on the verge of disastrous 'contributing to delinquency' charges because he insisted on keeping his house open to his sons' crazy friends. We sat up all night talking about the nightmare of 'polarization' that was coming on us all ... And the next morning I had to drive to Detroit in the snow at about 90 mph in a goddamn useless fishtailing Mustang to catch a plane for Aspen."

3-16-01

Dear George/Patti/Ben,

It is early Friday morning & we have just returned from a wonderful night in
your elegant, life-giving Pool/palace that I have loved for so many years. It
is a Magic place for me, and I want to thank you for it again, and again, and
again, etc … It is a Treasure to me, a vital psychic Anchor in my life & my
happiness. Our boy Sam Coleridge wrote a poem about it once:

"In Xanadu did Kubla Khan a sacred pleasure-dome decree – Where Alph the sacred
river ran, through caverns measureless to man, down to a sunless sea…"

Sam was weird, in his way, and he came close to death Many times in his search for
that Edge that only a few of us are crazy enough to walk on.

Ah, but so What, eh? That goddamn pool almost Killed me last night. I had stayed
away for so long & missed so many dumb nights in that water that my heart almost
Burst like a bomb when I came back at top speed & tried to make up for it all at
once … Fuck that place. It is too much Fun for an elderly dope-fiend like me. My
blood ran fast like a Hummingbird's, and I was lucky to escape with my life. It was
beautiful, and I thank you again for the joyous thing you created. I'm sorry if we
made too much noise & I promise to fix up that sorry-looking Plant-life ASAP. That
is as much My job as Yours, & have failed to keep up my Due Diligence.

Soon come, don't worry. But now I must sleep. It is almost Nine, so that's it for now.
We have big-time Basketball this weekend. Come on down for some fun.

Yr. friend,
Hunter

*we need about 3 more degrees of water temp

*The mind contains the greatest mysteries, far beyond anything we hope to search for in the entire universe. Is
consciousness an abstraction or a knowable reality? And does the state of madness provide more tangible insight into
the machinations of the brain, or push us even deeper into the void?*

*Whether one's madness can be converted into a bankable career, or can keep one locked behind societal compounds, is
inconsequential when considering insanity. But it does tell us something about the value we place on performance.*

George once remarked that Dr. Thompson used drugs, as George uses alcohol, to quiet his nonstop internal commentaries.

I wonder if insanity can be defined then by voices alone: by whether one can identify and categorize the voices, or if one is controlled and overwhelmed by them. For who doesn't either ignore or succumb to obsessive cerebral messages that pierce everyday interactions?

September 19, 2000

Hi Dear George + Patti + Ben,

Hope all is well. Ben in High School now? Just had time to write. I like to write to you George.

I think I told you, I'll have an ECT every other week now. Then what we're aiming for is one a month.

I was Hearing Voices last weekend the 8-9th. It was Thundering + banging + booming. I was at my parents' house for a visit on that weekend.

It's always the same story. Jesus is coming. Is what the voices are telling me. And I'm the "chosen one." Doing my work for Him.

But since I hadn't had an ECT in more than a week, the voices come on.

And on the 13th Sept when I saw [my doctor] at Munson Medical Center, for my therapy, the anesthesiologist didn't put the thing in my mouth, to hold down my tongue when they did me. And I had a convulsion during the ECT and I bit my tongue! And after I recovered and got dressed. Nobody said anything to me. I didn't know until I was at home and my tongue turned Black + Blue and swollen. And spitting blood. Sue panicked and took me to Emergency. We waited there for 3 hrs. And the anesthesiologist came back and looked at it and said rinse with saltwater about 8 times a day and don't drink coffee for a while. Oh well. It's better now. But I'll remind them to put the boot in my mouth!

I've made friends with the DJs from WCCW 107.5. Oldies FM. Charlie + Dave + Mike. I call them once a day and make my request. They play it. I won a T-Shirt for guessing John Lennon's 1st wife's 1st name. It's "Cynthia." That's what I knew.

There's 2 old men here at my house that want to Marry me! I don't know?

I want to get this in the mail it's almost noon.

So take care. Say a prayer.

See ya,
Cynthia - "Eddie"

Perhaps it's the non-sequitors that are more frightening — when one can't draw a straight line from one thought to the next. But isn't such unpredictability the mark of creative genius? And isn't our world so far gone that those who believe sanity actually exists are truly the crazy ones?

7-26-02

George - Why is
your car from
Stevinson Toyota?

And why is Patti's
car from Buckhorn
Toyota?? (Big Horn? who knows?)

It has puzzled us for 3 hours.

Now I am
hungry.

Do you have
any hashish?

Love,
H

why am I cold?

Who is Jesus?

Are all descended
from Jews?

Where is the
Deviled Ham?

In Jail we ate
it on crackers

Nice Rain Tonite, eh?

Anita stepped

in dog-shit
+ went crazy

Are you a Jew?

I want to
buy the tree
farm on credit

I have some
white hash that
is scary

Who owns the
Rain?

Why not put in
a deep end +
a diving
board?

Off the Pig.

OK H

Mother nature battled here eons ago, an immense upwelling of hot igneous rock rose underneath thousands of feet of maroon sandstone. What is thrust up is eroded and washed to the Gulf of California by the mighty Colorado River. The great forces that removed all traces of the sandstone now, more gently, work away at what remains of the intrusion, the granite.

It's still nature's eternal conflict, earth heaving itself up and then warm rains softly returning the landscape to the way it was. Beautiful and peaceful as all conflicts could be.

————◆◆◆————

Only a philosophy of eternity, in the world today, could justify non-violence.

A. Camus

————◆◆◆————

...L'eternité.
C'est la mer melée
Au soleil.

A. Rimbaud

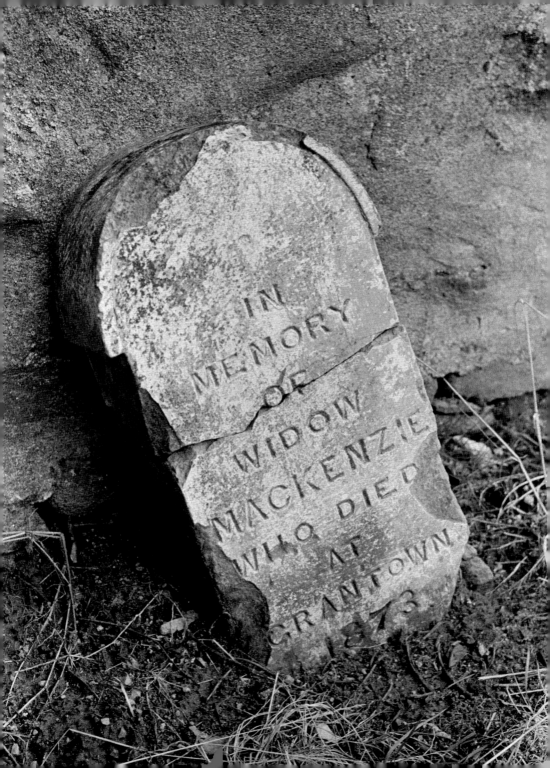

It's a group therapy weekend, and the shrink popped this unexpected question: "What does it say on your gravestone?" He's going around counterclockwise, I'm about fifth in line. Time to think about it, no, time to close my eyes and try to visualize my gravestone. It's dusk in the cemetery and the unmown grass made it hard to read the words: "He tried."

"He tried? Is that all?" The shrink acted out a failing attempt to get out of his chair. "I can try to get out of this chair, or I can get out of this chair," standing up in triumph. OK, I get the point, the difference between trying and doing. I feel a little shame, but also some anger. After all, I simply reported factually on what I saw on that gravestone, why make fun of me?

I stayed quiet after that. When it came time to tell dreams I couldn't or wouldn't think of any.

———◆◆◆———

No, Ernest, don't talk about action … It is the last resource of those
who know not how to dream.

OSCAR WILDE

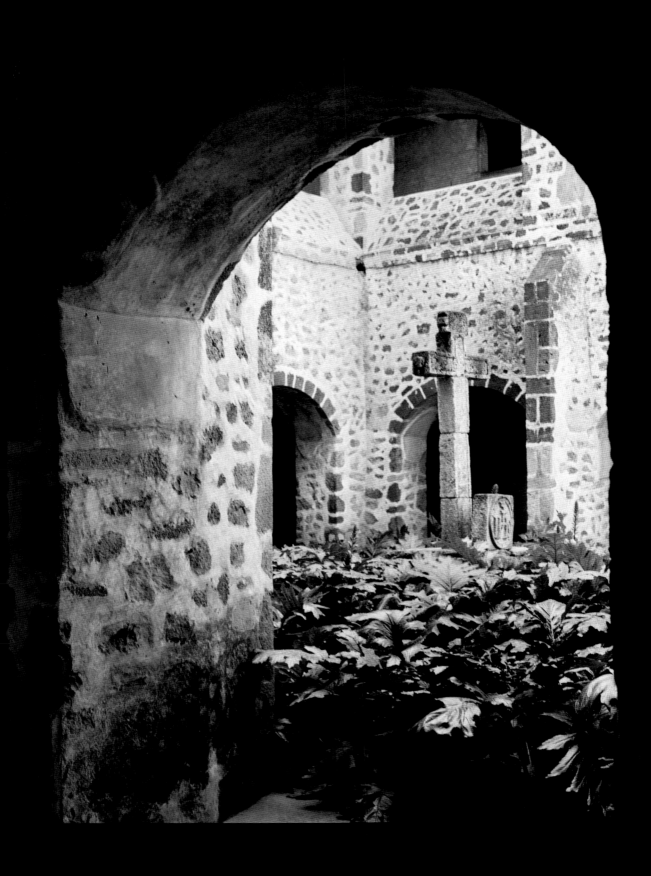

Things got worse for Angelina after the Holy Water incident. Under the influence of Father Jorge and Sister Beneficence Mother Superior began to doubt the strength of her calling. At first she prayed for Angelina, and then she prayed with her.

The other nuns, noting the extra attention given to Angelina, felt jealousy and snubbed her most cruelly. Angelina grew unhappy and also began to doubt the strength of her calling. Mother Superior explained that doubt had always been God's way of testing faith, and Angelina herself and only by herself could pass or fail that test.

A cheerlessness crept into the convent. The Bishop was called. He came and passed this judgment, "Angelina must be transferred to Our Lady of Mercy where she will be trained to become a teacher."

The transfer was quickly accomplished. The Sisters of Our Lady of Mercy knew of neither the Holy Water incident nor of Angelina's struggle with doubt. She was cheerfully accepted, began her classes and pushed doubt into a secret corner of her heart, where it nestled like a sleeping kitty on the hearth.

—◆—

Life is doubt, and faith without doubt is nothing but death.

Miguel De Unamuno y Jugo

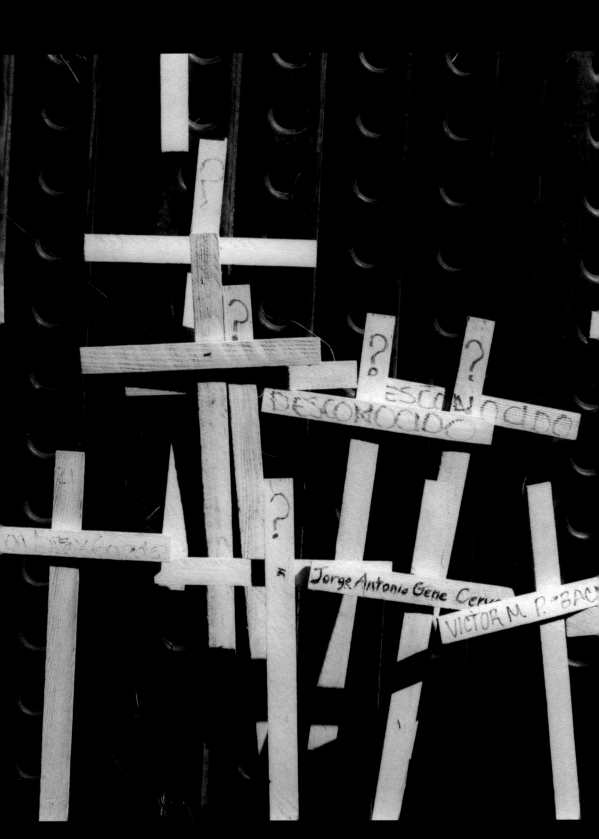

Immigration reform has been on the lips of politicians for a long time now, and yet we wait, a nation quite divided. Perhaps we wait because as a nation we don't know how to talk it through.

———•◦•———

Politics, a weighing of dreams against fears, is a civilization's dialogue with itself.

Wall Street Journal

———•◦•———

Politically, we are polarized from left to right while society itself is organized from top to bottom. The immigration issue is clearly about this top to bottom structure, though not without plenty of skew left to right. One of the reasons we have trouble talking through top to bottom issues is that it's about privilege and oppression, the established and those not. Top to bottom discussions can emphasize liberties above justice…

So they talk instead about a fence along the border. I've looked at what currently exists of this fence and it looks just like this photo of the Mexican side in Nogales. It's the air force's temporary landing strip panels; metal, about twelve feet high, and to save weight and costs, has these holes that serve perfectly as hand and footholds.

The white crosses are placed on the wall by the families of those that have died on the other side. The same white crosses are found wherever the fence has been completed, and there are too many of them.

You have a job and bring home a paycheck, net of the deductions to pay for your government, your retirement and your healthcare – all stuff "for your own good." You are buying your own house. Not making payments to who previously owned the house but to your bank. An intersection between labor and capital.

Employees have employers as owners with a self interest and competitive advantage to be gained by minimizing the amount on that paycheck. Another intersection between labor and capital. These intersections, in the end, determine one's class, upper, middle and lower. We celebrate our independence day partly because that war won the right for this definition of class as opposed to class determined solely by heredity.

Yet a fortunate or unfortunate birth can strongly affect the job one gets for generation after generation.

———◆———

Home is a name, a word, it is a strong one; stronger than magician ever spoke,
or spirit ever answered to, in the strongest conjuration.

CHARLES DICKENS

This fall day, 1983 in Skardu, Pakistan, we knew exactly what we had to do. We went to the police department and our sirdar Mohammed Ali bought drugs from the chief. Some of the hashish we will use ourselves on the Baltoro glacier, most we will give to the porters. To grease the chief in this manner is a necessary passage to the glacier; he was pleased and invited us to his villa for afternoon tea. The view from his porch across a lake and up to Himalayan foothills was spectacular; the tea was good and so was his English.

Today, sorting negatives twenty five years later, this one stirs memories and one memory dislodges the next, and so on. Looking over the rim of my cup of morning tea I see a lake and Himalayan foothills beyond.

———•◦•———

Our memories are card indexes consulted and then returned in disorder by authorities whom we do not control.

CYRIL CONNOLLY

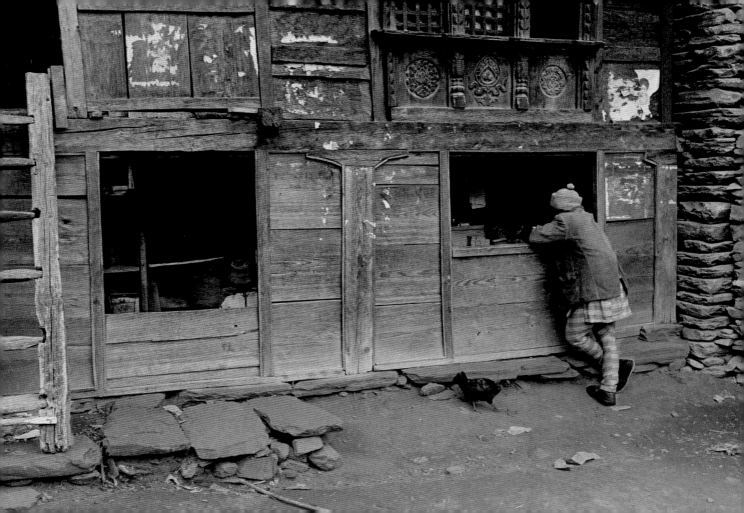

We passed through the last village of Syabru on our way to Lantang along the Nepal/Tibet border. The village lies down a steep ridge and ladders are used to negotiate the main street. We set up camp and sent a request to speak to the mayor. Shortly a lady, the mayor, appeared and Shambu translated our request. "We would like to buy all of the raksi in the village and to share with all of the villagers in a party to be held at the gompa."

Her honor said that $5 in rupees would secure the raksi, the gompa and that the villagers wished to sing and dance with us. Shortly after dark a five gallon jerry can appeared followed by most of the adult population. We drank, we toasted, we sang Risom Pi Ri Ri, and soon the raksi demanded dance. Arm and arm we jammed the gompa porch. The steps were chanted: "left, left, back, back, right, kick, back, and repeat." I was in love: with the ladies under each arm, the songs, the dances, the village, and the world. And, at that moment, the world was in love with me.

Late, we saw a candle glowing from inside the gompa and asked about it. She explained that the family of the deceased and the monks were holding a nightlong vigil. We asked forgiveness in partying in such a place and on such a night. She said, "He didn't mean to die today," and we danced on.

<div align="center">⋘•◆•⋙</div>

<div align="center">

Yet nightly pitch my moving tent,
A day's march nearer home.

JAMES MONTGOMERY

</div>

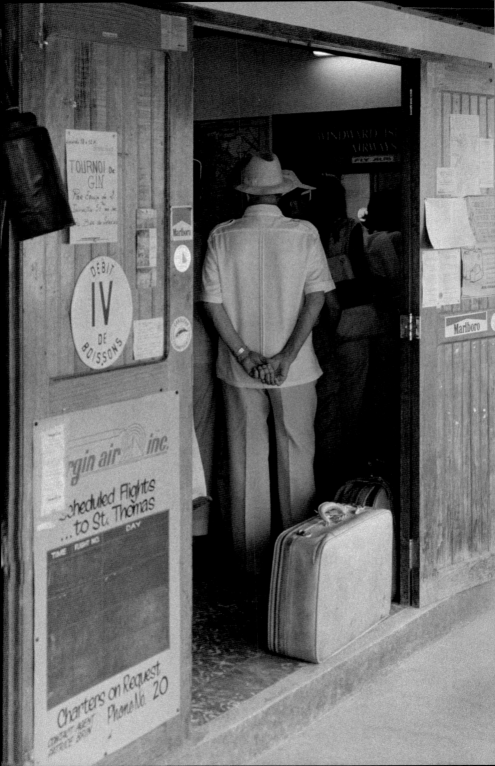

A little airport on a little Caribbean island, the airfield is short, the plane will hold only eight passengers. There is no x-ray of the luggage, no magnetic screening for weapons, he'll leave his shoes on. If he were to change planes in Miami these things would be done then. But he is not changing planes in Miami; he will get on a bus there and go to Atlanta. He is comfortable with the odds that customs will not check his one small bag.

His daughter lives in Atlanta and she has married a man that he intends to meet for the first time. This manner of marriage, without a father's approval, without the village celebration, does not sit well with him. He has cosseted a little mouse of anger that has grown now into a snarling bobcat prowling his skull relentlessly.

———◆◦◆———

The past, like so many bad poems,
waits to be reordered,
and the future needs reordering too.
Rain dampens the brick, and
the house sends up its smell
of smoke and lives.

HARVEY SHAPIRO

The well digger was the unofficial mayor of Cardonal, oh, for the last twenty years. In Cardonal well digging is done with a shovel and a bucket; he dug down and hauled the stuff up to be thrown on the beach.

Church every week, one wife, seven children, fifteen grandchildren, and so much gusto at the table with the family. From the head chair he told his stories, often stories of fishermen lost at sea, but many also of people with good fortune; a fat pig found in the woods and taken to market. This is his home, and his chair has been retired from the table and placed against the wall.

And what happened? One day he could not pee and thought nothing of it. But the next day was all pain, and he went to the bus stop to get to the doctor in Las Barilles. It was there that he collapsed. Angelina happened to be there, on her way to buy beeswax for more candles, and held her cheek next to his as he died, and whispered to him, "You have done all that you needed to do."

———◆•◆———

Let us go in; the fog is rising.

EMILY DICKINSON

5. OUR WOUNDED

My definition of learning is "To be different tomorrow because of today's experiences."

At one of our recent meetings, George brought along his photo of Eddie (Cynthia) from the last time she had visited him in Woody Creek. She is topless but wearing jeans, chest down lying in the grass, cheek against the ground, long hair hides her face, at peace, perhaps asleep, yet there is no denying an electric sensuality in her pose. Although the photo is in black and white, she appears tan. George proceeds to show me a more contemporary, standard Kodak color photo of her, Christmas 2006. Eddie's extended grin and shiny skin match the four older Midwestern women beside her; they are all aglow in plastered make-up, the flash from the camera further embossing them. You would never suspect the chaotic reruns that possess her. It is only her handwriting that gives away her secrets: cursive loops lost into stunted, erect letters, blaring cross-outs — acknowledged mistakes, and abashed apologies.

12-9-07

Dear George,

How are you? Is therapy still happening to you? You asked me once, to remember something funny. Back many years ago now. Something funny. Was Marion B's son sitting on your lap just a farten her ass off. Pop pop pop. I don't know if I spelled her name right. But that was funny.

Well Mom; still doing chemo. 4 more treatments. She's her normal Busy Busy self. Almost all her hair is gone. Bought a wig. My schizophrenia is still around. Somedays good, some days worse.

Merry Christmas.

Hugs + Kisses,
Cynthia O.

My writing is awful. A lefty.

P.S. Still smoke

"Have a Merry little Christmas"

George explains to me that Eddie is his way of staying connected to the other side, to the other side of sanity. It is his way of taking care of the wounded, different than the military's taking care of its weakest link, but a community member's watching out for its own — the shepherd and his wayward sheep, perhaps.

My last year as a draftee was spent in NEI company, New Equipment Introductory, and everybody there was a college graduate draftee, i.e. not entirely happy with their situation. FTA began slowly and softly, we'd whisper it, then in shaving lotion on the bathroom mirror, then perhaps in the dust we might leave as we cleaned (not) the battalion commanders desk. A real hero patted the Colonel on his back and left an FTA sticky note. Nobody didn't know that FTA stood for, "Fuck The Army." I witnessed a true breakthrough arriving at the post one day at 5 am to see the parade field ablaze with burning coal laid out in the letters FTA. This was a bit much for an army at serious war in Korea; the CID came in from Washington to find and punish the perps, which were all of us. New guys are easily recognized and not soon trusted, the CID learned nothing. The army is dumb, but not entirely innocent of how to deal with our ilk of saboteurs. They transferred in a combat hardened battalion commander who fell us out at 5 am in dress code, 6 am in fatigues, 7 am dressed for parade and so on. I was able to transfer out.

Eddie is George's digging down to the very bottom of complexity, the scientist delving into the unknown, a metaphor for the passionate child whose profound focus on one subject teaches her everything she ever needs to know about the larger world.

This was all a bit safer than my lock picking of an air force recruiting gizmo, a jet plane on a flat bed. We dissidents determined to drive the recruiting device to the AFROTC Colonel's home and park it on his front lawn. With the lock picked, it was driven to the destination passing under an overpass that unfortunately removed the empennage, the tail of the bird. Destruction of military property during wartime; the FBI was on it by the next morning. They promised vast amnesty for snitching, and promised a firing squad for the offenders. Remarkably we held.

I question what side of sanity Hunter Thompson was on, and George says that he and Hunter are on the same side, and that Eddie is a reflection of the human condition in today's world. And then I am even more confused about who the sane ones are, or if that concept has any real meaning at all.

Most of what we each know is personal knowledge. I know my home in my own way and as a result of my experiences there. Patti and Ben know the same place in their own individual ways too, as a result of their experiences. Our knowledges are not the same, and, in fact, can hardly be compared with any others with any degree of accuracy. I have my favorite chair and it feels "just right" because of memories I have of Ben falling asleep on my lap and me with a cold one near by and a dog licking my hand. I can tell Patti or Ben about that experience, and they can nod and say, "yeah." Or they can relate something similar about that chair or something else in the house, and I can nod my head and say, "yeah." But even if we describe almost identical experiences, there is no way that we can identify that the feelings that we had were identical. We try to use words, but there's no way to determine if any two of us have the identical "understanding" of the meaning of any particular word.

It is assumed that learners have to construct their own knowledge – individually and collectively. Each learner has a tool kit of concepts and skills with which he or she must construct knowledge to solve problems presented by the environment. The role of the community – other learners and teachers – is to provide the setting, pose challenges, and offer the support that will encourage construction.

[*From Hunter Thompson's daughter-in-law, dated three weeks following Hunter's suicide at his home in Woody Creek.*]

3.15.05

Dear George and Patti,

As Juan + I slowly venture back to life-as-we-knew-it, we are remembering the tangible Love and support we received from you during the worst week of our lives.

I cannot imagine what would have become of us without your presence in our lives. Thank you. Thank you for allowing us the use of your beautiful guest house and for the generous flow of food + Love –

We are blessed to have you two in our lives. Your kindness will never be forgotten.

With much love,

Jennifer W. Thompson

[During the] high school years for Eddie et al, they felt safe enough in my home to talk to me about their lives. I think they felt that way because somewhere along the line I had learned that occasional grunts of approval or mild surprise were good listening skills and that judgments were not.

Some of their stories that have stuck in my mind:

They told me about Doc Varner. Her son lived in the basement under a pool table. There was a drum set in a darkened corner of the basement and the son would slide out from his greasy sleeping bag under the table and play. Doc gave warm saline IVs into teens' femoral arteries. Jules said she had tried it once and that "it was a great sex rush." Doc had lost her license to practice but evidently not her IV equipment. While I feel creepy-crawly visualizing this scene, the kids acknowledged that it was weird but still within their realm of acceptance. I believe now that what actually happens in children's lives tends to become their norm.

They told me the story they called "Just Another Night at the Sub Villa" which was about the mall parking lot by the sandwich shop where they liked to hang out. One night the place erupted into a juvenile

throw-anything, trash-anything mob and the kids ran away just as the cops showed up. They were excited by the mob they had created and the cops who deemed them a problem. This was 1971 and I, and many in the university where I taught, were deeply into the anti-war movement. I asked the kids if the riot was about the war, and they said no, it was just about fun. That was the year after Beth died, age 16, of a brain tumor that drove her – and her family and friends – crazy towards the end.

E.J. Kapella was the shop teacher in their high school and also the driving instructor. They told me about throwing a bunch of .45 shells into the stove he used to burn the shop's sawdust and what it had done to his temper that day. They hated E.J. It seems strangely paradoxical that someone who maintains anger and negative relationships with youths would choose a profession working with teens. E.J is not at all alone in this category of teacher.

They told me about Mr. Purvis' science class where he let them look at blood, spit and things through microscopes and the iguana ran free. They called Mr. Purvis "Scotty" and they loved him. Once the kids tried using the chemistry equipment to distill some hash oil; Scotty just didn't want to know about it.

Even though they didn't particularly respect him, the kids liked the English teacher, Mr. Oberlin, because they all knew exactly how to prompt him into totally dropping the lesson plan to tell World War II stories. Everyone in the school had heard the stories before, but it was always better than the lesson plan.

They found high school irrelevant to their current lives and to what they anticipated to be their future lives. They didn't respect their teachers (except Scotty), the administrators, nor the school property itself. They defaced school walls and lockers, stole if they thought they could get away with it, and were rude and confrontational to teachers they didn't like. Nor did the school (except Scotty) respect them; they were not "good" students.

(We should also say something about an ethical attitude that must accompany constructivism. We want children to care about mathematics and to care for each other. To accomplish these goals, we have to care deeply for children. As the poet Goethe said, "We learn best from those we love." Time spent on the development of caring relations between teachers and students is time well spent, and we need to get away from the idea that teachers must spend every minute on instruction driven by precisely stated objectives. Just as "messing around" with mathematical ideas is necessary to mathematical thinking, dialogue is necessary to ethical life and, therefore, to teaching. Children who feel cared for are more likely to engage freely in intellectual activity.

When we open ourselves to caring relations, we learn to listen. Then we become convinced that constructivism is fundamentally right: students do think, and they actively build representations in infinite varieties. They find ideas in working purposively with concrete objects, in talking with each other, in sharing with their teachers. Mathematical growth, like ethical development, is varied and complex; it is under continuous construction

and depends, ultimately, on whether students care about mathematics. And that depends, at least in part, on whether we care adequately for them.)

"Above everything that I am," George says, "I am a teacher first." This must be the reason why I am in George's life, I think. I have never had a teacher with whom I have truly connected, whom I felt cared for me, and would remember me after I had left the classroom. Didn't it seem that all successful people could point to a specific teacher who opened doors for their self-discovery, someone who showed them the way to self-confidence and dream-believing?

Eddie is semi-institutionalized receiving electroshock therapy in Grand Rapids.

Patrick is an unpublished writer living in Bozeman.

Felicia (now spelled with an e) is a single mom raising two sweet kids in Holt, Michigan.

Jules is peddling custom-knitted hats.

Kevin put some time in on the fourth floor of Sparrow Hospital (the mental ward) and after that he left my radar screen.

Wronsky worked his way into upper management at a nursery franchise.

Bill had a head-on into a telephone pole, drunk. I think he was 21 when he died.

Doug, after years of living in the non-tax-paying "informal economy," now owns his own dry-walling business.

Spunk died of a heroin overdose.

Purvis? Happily retired I hope.

Me? I learned a lot. I learned to accept adolescents for what they were and not for what I wished them to be. I learned that tolerance requires a daily dose of renewal. I learned to listen and they learned to talk; a fair deal, I think. I learned that many, and not all, kids are alienated by the white suburban high school of America, and I learned that acceptance of the world as it is is not compulsory.

George has never visited Eddie in Michigan, at the institution. He admits that he doesn't really want to get that close. Eddie has often written George's son Mark who lives in Michigan, but Mark has never replied to Eddie. Mark has his own issues, George says.

3-26-08

Hi Dear George,

What a lovely surprise!
My sister Linda is going to frame it + hang it in my bedroom. Thanks.

The voices are around a lot. But it's getting better everyday. I do believe in God.
And he's a busy man. And I do have to get out more.
There's a party for everyone sponcered [sic] by the W.C.C.W. people. This weekend. And
my sister Janet is going to be up here from Grand Rapids to help Mom with her
chemo therapy. Me too.

Her hair is growing back. She looks pretty even without hair.

The floor needs sweeping.

Tomorrow is my day to do my volunteer work at the Pavillions. I play Bingo with
the old ladys [sic].
Mostly women in wheelchairs.

You know, I think of you just about everyday.
In the bath. The sauna bath.
You know I hear your voice when I'm hearing voices. And what I call the John
Lennon Jesus war.
Did you know. Rock n Roll.

Thanks for the picture.

Love ya Cynthia.

It is the picture of her that she is referring to, the one where she is laying topless on the grass. George recently mailed her the print.

I think that when we pay attention to our wounded and ask "Why?" we find an agenda for change and even the angry energy to attempt what is necessary for change. And what are we called to do? Celebrate the winners who didn't get hit, or take care of the wounded that did and see to it that it never happens again.

"And Yael," she said, "Do not ever forget and do not ever tell." And Yael said "Yo," meaning what guys mean when they say "Yo." She heard this as, "I promise on my honor and love for thee." When the snow finally slid off the north side of the roof he left for awhile.

Spring came early and grandly, tanager and bluebird, and every day a bit greener and longer. Her friends described her as "weepy" this spring. She didn't speak of it, though her dogs seemed more protective than usual. In May, they shared a lunch of morels and sweet early watercress, they talked of books, Jim Harrison and Hunter Thompson. When he left, no embrace at the door, the cat slipped out between his feet.

All healthy men, ancient and modern, Eastern and Western,
know that there is a certain fury in sex that we cannot afford to inflame,
and that a certain mystery and awe must ever surround it if we are to remain sane.

G.K. Chesterton

I see footprints, and some are mine, faint dents in the sands of time. There are others, I know not whose, or even when impressed. I stamped my foot once or twice wishing to make some deeper marks and got sand in my shoes. The little gust that erased my footsteps blew grains of sand into my tea and I drank them.

"The sands of time," timeworn, yet we understand that whether we are one or few the landscape endures and our footsteps not. Our passage is barely marked and soon erased in the larger scheme of dunes and cosmos. Even so, I think, we might tread more lightly. Let us leave our marks within ourselves and each other.

———◆◆◆———

And some there be, which have no memorial; who are perished,
as though they had never been; and are become as though they had never been born;
and their children after them.

Sirach 44:8-9

———◆◆◆———

Baby sister, walk with me.

There's backpacking and there's truck camping and all manner in between. As my back gave out I became savvy about the latter. I rigged my ¾ ton 4 wheel drive jimmy with a frame over the bed that held a plywood sheet strong enough for myself and view camera. Newly divorced I packed three sons, a nephew and one dog, food, beer and a Ruger 357. There was no one to ask, "When are you returning," so we didn't have an answer to that question.

Desert folklore says that circling a campsite with a hemp rope will keep out rattlesnakes, it's just too scratchy on their bellies. We did this every night and one evening as we enjoyed steak and cold beer we discovered that we had fenced a rattler inside the rope. It was shortly dispatched with the 357. We tied the snake to the side view mirror and reckoned that that and our grubby clothes made us look and smell like seasoned desert rats.

A desert thunderstorm is awesome in its approach, yet leaves so little behind. By dawn not a trace, no dew, no smell of freshness. Finally the 12 year old said, "I want to go home," and we returned to an empty house in Woody Creek.

<p style="text-align:center">—•◦•—</p>

All night, this soft rain from the distant past.
No wonder I sometimes waken as a child.

TED KOOSER

A half-day's drive West is Goblin Valley, Utah. The geology is self-evident, harder sandstones lying on top of softer ones, and then erosion happens. Many go there to wander under starlight through these stone mushrooms, perhaps with magic mushrooms or other hallucinogen involved in the mind. We humans have an old, probably primal, habit of adding extra molecules into the stew of neurotransmitters that constitute our "normal" minds. Apparently normal human behavior includes a proclivity to have abnormal mind experiences, to get "weird."

Evolution would dictate that we are what we are because we are fitter for survival because of what we are. So, why does it make us more fit, this propensity to get weird? I'm not here to make excuses for human behavior, merely to understand the beast. Next to burn, rape and pillage a 'shroom seems innocent amusement. The human capacity to adventure, to explore, to try new things has been our evolutionary advantage. Weirdness is just our personal adventures within our minds, an exploration.

And then I lay me down to sleep a human being to awake the next morning still a human being, even exactly the same one that I lay down the night before, and the night before that too.

I am what I not yet am. Maxine Greene explained to me.

UNITED · WE · CONQUER

IN MEMORY OF
THE OFFICERS AND
MEN OF
THE COMMANDOS
WHO DIED IN THE
SECOND WORLD WAR
THIS COUNTRY WAS
THEIR TRAINING

Nine years after the nuclear bomb fell on Hiroshima my basic training for the next war in Korea included a morning leaping over a trench and bayoneting sacks stuffed with straw. Good grief! This is ridiculous, what am I doing here? I'm a draftee being trained to go abroad and kill gooks, or perhaps to be killed by gooks.

I am learning obedience to command, to dress according to code, to march to a drumbeat, to salute the flag – in short, I am watching myself being brainwashed. At first I thought I was only obeying to avoid punishment. Gradually I came to recognize my own identity as a soldier, a dog tag numbered US 52371139. I thought seriously about volunteering for the airborne. If war is hell, aren't soldiers agents of the devil?

As long as we celebrate, decorate and honor warriors we will have as many as any politician could possibly want.

———•◆•———

Every gun that is made, every warship launched, every rocket fired signifies, in the final sense, a theft from those who hunger and are not fed, and those who are cold and are not clothed. This world in arms is not spending money alone. It is spending the sweat of its laborers, the genius of its scientists, the hopes of its children.

Dwight D. Eisenhower

Twenty four years ago I landed in Karachi, Pakistan. I prefer the relative anonymity of the terminal bathroom to the long aisle walk on the airplane, and had a full bladder and considerable urgency on arrival. Universal signage helped to find the men's room and its welcoming wall of urinals. There were guys hanging around or doing their business when the muezzin call to prayer blasted out of loudspeakers everywhere, including this men's room:

Allah u Akbar, Allah u Akbar

Ash-hadu al-la llaha ill Allah...

They dropped onto their knees, every one of them, foreheads to the floor tiles. The wall of urinals now had a prostrate guy blocking every one of them. I pondered straddling or possibly standing on the back of one, but that struck me as even more awkward than the imminent possibility of peeing my pants.

The tungsten light reflected off the pea green tiles and fell on the backs of the prostrate men. It was strangely eerie. In increasing discomfort I wondered what kind of a church had I come to here in Karachi?

———•◆•———

Much later prayer became asking the inconceivable from the improbable.

Jim Harrison

Birmingham, Alabama: the Civil Rights Museum causes more than mere memories of news clips and press photos. The intensity of the experience can leave you both weeping at tragedies and raging at savageries. "Never again," you say, and as you walk past these white statues of unity you think that maybe "never again" could someday become our reality.

The day before this museum tour we sat in a church to hear about the continuing battle against racism. We know enough of man's inhumanity towards man to know that "never again" is an ongoing struggle. Angie was speaking of the difficulties of the struggle and of the occasional small victories. She stopped for a second, looked at the ceiling and said, I think to herself, but out loud, "It takes courage to hope."

━━◆•◆•◆━━

Blessed is the match that is consumed in kindling a flame.

Hannah Sanesh

COOPERACION
DE LA
CAMARA
NAL. DE
COMERCIO

Do you see Xavier? He's in the white shirt, first row, furthest right. He's a little bigger than his classmates because he's been held back — twice. Xavier doesn't like being schooled, always being told what to do and how to behave. He learned to read and write along with the rest but pretends that he can do neither. He intends to stonewall on this ad infinitum; he reckons that in about one more year his teachers will figure out how to "lose him" from their school. Already they have begun to lay off a bit, he senses they are beginning to give up.

Perhaps because he has resisted the "work hard and do as you are told" model that his school requires for success, Xavier maintains an extraordinary curiosity and imagination. His parents have granted him the luxury of a cat, Sancho Panza, to which he whispers, in impetuous rushes, his dreams for the life ahead, the life he is sure will be precious and have meaning.

———•◦•———

For some, not learning was a strategy that made it possible for them to function on the margins of society instead of falling into madness or total despair.

HERB KOHL

A nice little motel on the California coast offers a nice fruit breakfast with plenty of coffee on a nice porch. We came here so that she can go to yet another weekend psychological workshop. Her former boyfriend's big brother was the shrink/facilitator for this one, and I found myself fond of him. I went with her partly as company and mostly out of curiosity.

This particular workshop was in the style of Eric Byrne's Transactional Analysis; nobody is either sick or even just stubbornly wrong, they're just confused and want to understand how come the same shit keeps coming around time after time. They tell their stories, the shrink frames that in terms of transactional analysis, they wail, they hug, bark out anger and sometimes just sob. I learned not to be frightened but never learned how to participate with the same intensity that they did.

Nothing ever got "better" for her, and I wondered, silently, why she repeated so often what so apparently did no good. In the end I figured it was an addiction, rather like the alcohol.

———◆———

We are sheep in a tightening circle.
You come like a shepherd and ask
"So how are you?" I start crying.

RUMI

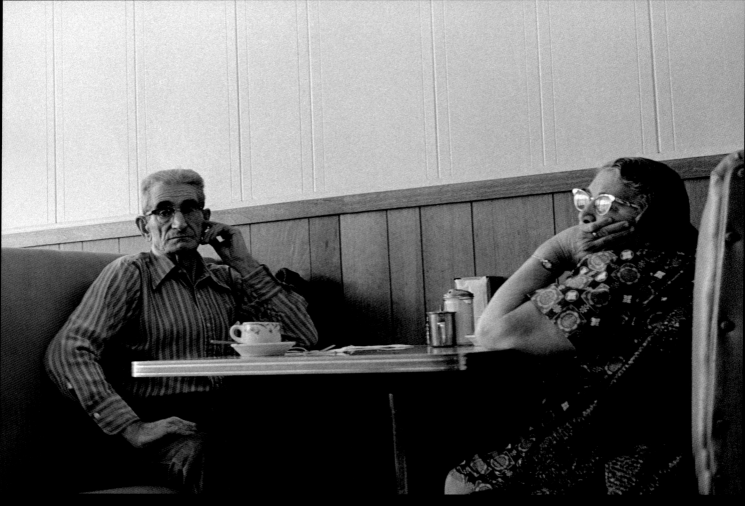

Forty three years today they married, forty three years of the hard work of a run-down farm, three kids, one in Iraq; nothing is going to change much for them from here on out. Surely there is nothing left unsaid between them whether in passion, kindness or anger. They are afraid; any truth said now is more likely to recall a pain than a pleasure. Silence is safe, and the eggs here are good, the coffee too.

"Your brother coming over later to help move the cows?" Safe enough, and the day has been planned.

—◦•◦—

When we speak we are afraid our words will not be heard nor welcomed.
But when we are silent we are still afraid.

Andre Lourde

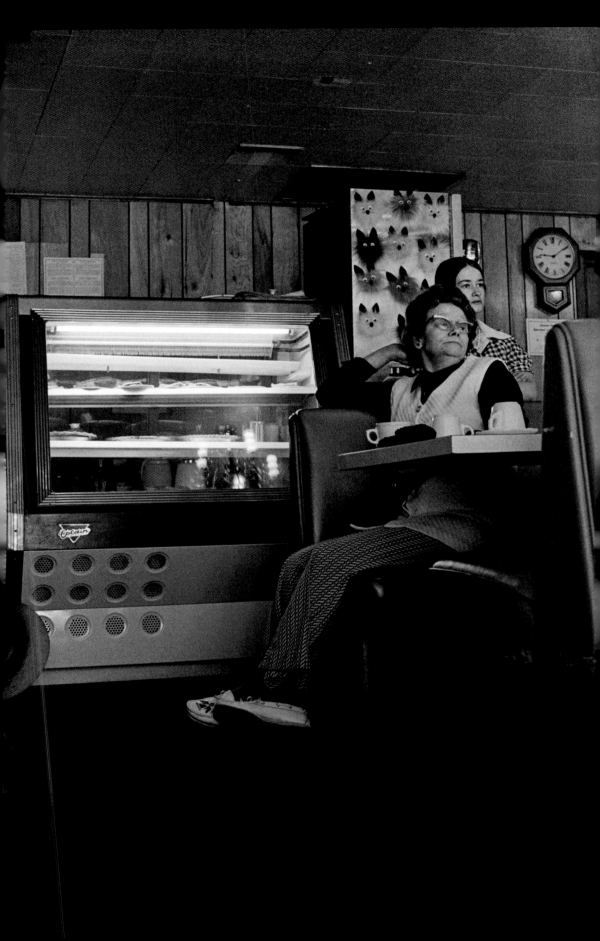

I am most at home in the America of Midwestern small-town diners. Their owners and their children work there and bake the pies too. The people who eat here know them and each other by name and are easy with each other. I am the stranger passing through and leave nothing behind but shards of cream pie on the plate.

"Herb, can we use your truck this weekend to haul that wood? Gotta replace a wheel bearing in mine."

"Cora, your daughter made you a gramma yet? She's past due ain't she?

I listen and wish this were my own hometown and I would gather firewood with Herb and soon be at a baptism. Couldn't I just stop here and not keep going to wherever I'm going?

"Thank you ma'am, and that was one great slice of cream pie. I'll tell my friends about it for when they're on the road." Get some gas and get going…

Pilgrims mourn to Woody Guthrie's hobo song: "I ain't got no home in this world anymore."

—•◆•—

Traveling is like flirting with life. It's like saying, "I would stay and love you, but I have to go"…

Lisa St. Aubin de Terán

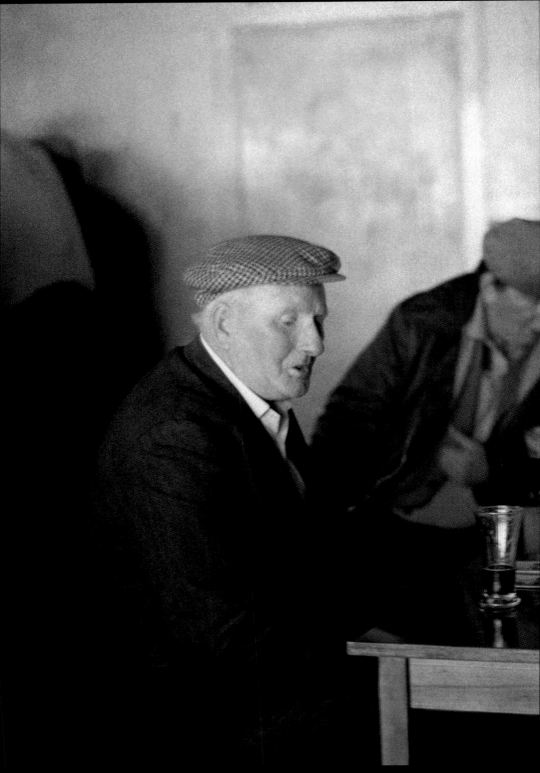

Spirited, like a frisky horse, that wisp of a tomboy in tenth grade or an activist. Spirituous – filled with spirit, especially alcohol. Yes, spirits, they so soothe the mind, relax the vise of reality, loosen the tongue and offer hope of companionship – intimacy perhaps. Indeed there is spirit, "the vital principle in humans, animating the body or mediating between body and soul" in spirits.

Ben Franklin noted that "Beer is evidence that God loves us and wants us to be happy." Evidence too of a gentle God that would let an old man sit quietly in his pub, with a pint, amongst his friends and regarding his own spirit through memories.

———•·●·•———

If you have a heart like the sea,
pick up the wine that reveals what being human is really about.

Rumi

6. AND THAT IT IS GOOD

I remember the kindergarten room, or perhaps I remember one event in the room that is so burned into memory that I also remember the room, the venue of that event. The light came from windows on the East and South walls, the entry from the hall was on the West wall, and just to right of that entry were shelves with educational playthings – it was, after all, a progressive school that believed that learning could happen through play. The second shelf from the bottom held the Lincoln Logs, the educational playthings of my memory.

Our teacher had a rule: don't start a new play-project unless you have put back on the shelves the one you are abandoning. I suppose that the rule made sense to me even if it was teacher imposed. So I had a nice structure going, the green flat sticks were doing something much more incredible than just being roofing, I don't remember what, but I needed more of them and went to that shelf to get more. Teacher loomed and said, "You can't start a new project unless you have put away the old; you may not have more of these green flat sticks until you have put away your prior play." I was devastated. I knew at that moment that teachers did not care for me. They cared for rules that I did not fully understand. And they enforced according to their own understanding.

I tell this in some detail that you understand how powerful these youthful events can be.

Education by far has been the most prominent subject of George's professional work and writings. His days as an undergraduate student of theoretical physics at CalTech, a graduate student at the Carnegie Institute of Technology, a post-doctorate at Purdue University, Associate Professor at Michigan State University, and then finally as a high school science teacher in Okemos, Michigan all thrust him toward a brutal awakening in 1972.

A lot of what I was learning from the high school kids who visited my house suggested that schools were an institution that needed major transformation. It was not serving its purposes for too many kids, if indeed it even understood its purposes. And I guess I was ripe for that message.

My boys and Falicia continued to have a tough time in school. The shrink said maybe they were smart and school was boring. I took them to a College Level Exam Placement (CLEP) exam. They tested at the junior level of college in English and science. We tried them in the university and that didn't work. We tried them at home schooling and that didn't work either.

Betsy, their Catholic mother was, I believe, as confused as I was by these times and circumstances. I think she fundamentally believed that these institutions such as churches and schools might need fine tuning but were generally the way things were 'spozed to be. She smoked cigarettes and drank either scotch or jug wine.

For spring break we sent the kids out to Aspen to go skiing. I went out shortly after to be with them and bring them home. Immediately, I got a handwritten note from Betsy: It was over.

So I just stayed in Aspen with the boys. It was spring break at the high school, new classes, new schedules, and they did fine without me. Maybe even better than fine. Mark and Patrick went to the Aspen public school. Because the new Aspen Community School (ACS) was in the physics center in Aspen I helped to start, I knew about ACS, their people and their progressive approach. Soon, Stuart and then Brie went there. The public school, Aspen or not, was no different than what I had just experienced. The Community School, on the other hand, woke me up to what could be, and I was captivated. And to this day, I'm still a captive of these ideas of progressive education and of the union between education and social justice.

When asked what typified their experiences while students of the Aspen Community School, graduates at their 20-year reunion responded almost unanimously, "You took me seriously."

Taking people seriously, if it's real, is caring; and for caring to work, it must be an active exchange between parties, and the exchange is legitimate only with emotional honesty. The impact on our lives of having lived this, taking, and being taken, seriously, was visible. How could a school that so marked our lives not be remarkable?

Even if George has been left somewhat broken-hearted with the end result of his founding leadership work with COMPASS (a nonprofit umbrella for Aspen Community School, Carbondale Community School and Early Childhood Center), in that it is not the pure progressive ideal he had imagined, COMPASS is unarguably a refreshing and viable alternative for a traditional pre-K to 8th grade education. As stated in its mission, "COMPASS is a setting for lifelong discovery, and a community of individuals who share a passion for learning, children and personal and societal responsibility."

In George's ideal, he constructed the following guiding principles for the school, as "they are the universal mortar that binds ourselves and our projects together:"

Leadership that facilitates; membership that participates; remember that children are why we are here; the work we do is to make the world a better place, for and with the children; a commitment to active participation in community decision-making; dream and do: embrace all possibilities; celebrate diversity with determined inclusion; transform the lives of a small number of people at a time; seek to know yourself and others through open, honest and authentic communication; strive to create an emotionally and physically safe learning community; make a difference in our own and others' lives through stewardship of, and service to self, others, community and the rest of the world; be accountable to self, others, community and the rest of the world; acknowledge your fears and what you intend to do about them.

"A parent would come and say, 'You know, I went to Catholic School and just hated it,'" George recounts, "and then they would end up saying, 'and I want your fifth grade to be identical to what I had experienced … I learned semi-colons in fifth grade, and Latin, and I want you to do that.'" And as principal of the School, George would respond, "Look, if you really want your fifth grader to learn semi-colons, I will personally give him one half-hour of semi-colons a week. Will that work?"

If I take your child into my time and space, a time and space we call school, our ways have become one, we tread the same path, and must plan together. And if we would do this we would be truly accountable. But life intervenes and we look for shortcuts, ways to get there without following the path itself.

The mind is the elementary unit of education just as the atom is the elementary unit of chemistry.

A proper school then offers a cafeteria of experiences that progressively exercise the different aspects of the mind, adding new capacity to the existing capacity. A fundamental belief is that no two minds are alike. Children, particularly, present us with a remarkably wide selection of minds-in-development. Their minds are incredibly diverse. We must celebrate each mind as we receive it and understand the possibilities that it can become. We must include that mind in the experiences of the school; we must mold those experiences to the very shape of each of those minds. The cafeteria of experiences offered by the proper school must not exclude any dimension of any child's mind.

The desired outcome is that each and every child's mind grows to its maximum capacity in each and every one of its multiple dimensions.

Perhaps such a progressive education could never attain George's ideal because it takes not only the teachers, academic administrators and children to live by these guidelines, but also parents and society in general.

I argue that we live in a society that discounts its youth beyond sense or reason and to the point where the society itself suffers.

Now I am a progressive. I believe that society can become better, that change can be progress, that progress is the ultimate purpose of being. The pursuit of happiness is identical to the pursuit of progress. And I see that I just wrote that societies that are progressive, that expect the future to be different than the present, have large discount rates and may apply that large discount rate to its own children.

My question is: do we apply the same discount rate we apply to things and ideas even to our children? I say no. If we set out to make progress for our children, then we may discount them. If we set out to make progress with our children, then we will value them as they are.

Throughout George's photographs we experience the discounted child who has still not found his place, the child who yearns for the unknown loving mother and searches for her everywhere: at truck-stop diners, mountains, deserts, his backyard, behind an open window, within stranger's eyes, outside convents, after gatherings, internally, and then beyond, to governments, graveyards, and drink. It is the expectation, the hope, that this lost affection is somewhere, today or perhaps tomorrow, that it can be achieved, and that it is every child's right.

In the perspective of evolutionary psychology my parents followed the imperative of mating, though I understand from later snips of information perhaps not in great agreement about frequency or violence.

They produced six children, the last perhaps being the only "accidental." Did was a women's right activist. I remember the several-day visit of the founder of Planned Parenthood. My parents weren't innocent of birth control – though I recall a moment with a birthday party balloon when my mother exclaimed in disgust her revulsion with things "rubber." I read that now as condoms, but who knows for sure.

So, I believe my parents made myself and my brothers and sisters by conscious choice as well as sexual urgency. The child rearing, the business of bringing us to the age of our own reproductive capacity, was farmed out to Miss Joss. I have to believe that Miss Joss had instructions for our rearing and was held accountable for them. I never overheard either the instructions or the feedback: "good job" or "don't do that again." If Miss Joss was accountable to Did, we were accountable to Miss Joss. She called the shots. At no time was there an appeal to the higher authority, her employer. None of this was unremarkable, then or now.

But if there are fissures between the parent and child bond, can the child truly heal this rift through others? Can we even be healed as adults, or is there a critical age when this transference must occur by? Can children be our healers?

There were servants at the Carranor Club, at the country club, and at my friend's house too; adults with the "power" that all adults have over children. They could order us around, tell on us. Because they were our monitors, they were the most likely to know our secrets – if you like, they were the Screws of our lives. If mom and dad were the warden of our penitentiary – our venue of penance, perpetual penance of non-adulthood, then the servants were the guards, the Screws, of our everyday activities.

There were two competing motivations – one, to figure out the system, get what we wanted in spite of the system, etc. and this meant knowing and understanding the servants, which led me to empathy for their lives. I believed then, as now, that my parents were kind and gentle masters. And the servants were cheerful rather than resentful in their work. But the work is not like a regular job where the employee is a player within a productive organization, providing a service or product that competes in a market. One might claim that the servant frees up the master from the daily drudgeries that they might be vastly more productive with the time thus freed. But the fact is that a regular job employee does things for the employer that either the employer cannot do, or that the employer is doing something else essential to the organization's mission. The servant does what the master could do and chooses to pay for instead.

How then do we separate the teacher from the parent, the parent from the teacher, especially if the parents perceive the teachers as paid servants and the teachers perceive parents or society as their employers? Should we – can we – expect the same from both roles, and then hold them to the identical standard: to love every child as one's own?

When every child is our own child, then there will be no more war. For who can bomb the homes of their own child, and who can drive tanks through the villages of their own child, and who can send their own child to study war against their own child?

Perhaps when we learn to love ourselves — that is when we will not only be able love every child as our own, but as our best self.

My mother loves her home, her place. It's in Perrysburg, Ohio, a village when I grew up, a town, nearly a city now, about ten miles up the Maumee River from Toledo, and just across the river from the town of Maumee … 577 East Front Street to be exact, and not in town, but at the edge of town. Dixie Highway lies North and South along the East side of the North-flowing Maumee River … I was born in Perrysburg, my first ten years were spent at 422 East Second Street, one block East and one and a half blocks South of 577 East Front Street.

My father, at age seventy, divorced my mother, then sixty-six. He moved away, and the place became my mother's alone, not that it hadn't been that all along; but now it was official. She bought more trees; the tennis court was replaced with dirt for more gardens; one Christmas we pooled together and bought her a little greenhouse to go just off her bathroom. To my mother, the promise of another spring, another growing season, seems to ameliorate the rather lengthy and grismal winter. She is never tempted to leave for a warmer climate; she waits winter out, planning, reading seed catalogs.

My mother invested a great deal of worry into what would become of the place when she was gone, passed away. For awhile, she hoped one of her children might move in; and then she worried that it would be the one with the wife that she didn't much like. She thought about giving it to the local university; I know that we talked often about this issue when I visited. Every possibility had some downside, like that wife that she didn't much like: it was nearly an obsession.

I don't think she ever hatched the full-blown plan of what was supposed to happen, I think little happenstances came along, and as they began to fit together, it began to make sense, and it was easier to see what the next step should be. Perhaps it was her friend Edith asking if she could use part of the Barn space for ceramics classes, perhaps it was my brother Michael's enthusiasm for Bio-Domes, but Edith spruced up the South section of the Barn and started ceramics classes, and a fifty foot Bio-Dome came from Colorado to occupy the center of the Circle. I have no idea who came up with the bookstore idea, but the North section of the barn became a community-operated used bookstore. Volunteers organize and shelve the donated books. There is a mayonnaise jar for the money, the door is unlocked, people come, find a book, leave a buck for a hardback, a quarter for a paperback, and half the profits go to charity.

A man had an automobile accident and suffered brain damage; he had been an executive in one of Toledo's manufacturing businesses. He could do bees, and he wanted to do bees. The Cottage became a bee center, and the man became a volunteer organizer for the activities around the Barn and in the Circle. Radiating away from the Bio-Dome towards the trees of the Circle are garden plots, each perhaps two hundred square feet; they are available to the community on a first-come, first-serve basis. One elder planted a garden with all white flowers of many varieties because she thought it would look beautiful in the moonlight. Another, a

father of several youngsters, planted varieties of African grasses in another plot. He thought the community would be interested in African grasses. Another gentleman went to a little clearing in the trees of the Circle, laid down and raked smooth some white pebbles, a placed a little seat at one end; someone else added a large stone at the end of the pebbles away from the seat.

In the Bio-Dome there is a worm farm with instructions: "These little gardeners like your garbage if it doesn't have too much grease." Everybody contributes, and children love to poke around and pull out worms for study and eventual replacement into the garbage. Somebody started a banana tree, and, by golly, even in Northern Ohio, it grew bananas! There is a community compost heap with a large visible thermometer sticking out so that the curious can discover just how bloody hot a compost pile can get when composting. There is a trail that runs from the Barn down to the Bayou; it is called "The River Walk" and various people have made little signs identifying the flora observed. There is a little wooden shack just outside of the circle on the South side where one can sit, and a sign that lists the birds that might be seen.

Others than Edith now offer ceramics classes; the Barn is busy. There are classes in making wooden chairs, classes on flower arranging, many, many classes about environmental issues, particularly targeted towards children. There are so many people out there who know something and offer a class. Children come from the mental home, a man with a stroke has been assigned in his therapy to make clay pots.

My mother's circulation is not too good, she smokes a lot and has her martinis in the evening. She can't walk from the Big House to the Barn and she uses an electric golf cart. She loves driving around the place. She loves driving around just alone; and she loves giving the tour: "And these Marigolds are placed here because they protect the asparagus from Leyden's rust." She has set up a foundation, the 577 Foundation, with a little endowment to pay for fixing things up and someone to keep track of classes, books, and gardeners. She is quite content with her place now, even a bit proud, because the Governor sent her a letter praising her for what she has done for the community; and she likes very much that she created what survives her before she passes away, and that it is good.

George's mother Mary Virginia Secor Stranahan died in 1997 at the age of 91. Because of inclement weather, George could not fly out of Aspen in time and therefore missed her funeral. One could say that even at the very end, George never did let his mother catch him.

And yet, if we can trace George Secor Stranahan's restless, and essential, loneliness back to his isolating childhood, we can also find early on along that same trail an ardent belief in justice, education and community, which has characterized his entire life. In this way, George is an extension of his beginnings, as we all are. Like his mother at the end of her life, George desires that contentment, even pride, in having created something good, and also, something personal, authentic, something of himself. Something for us.

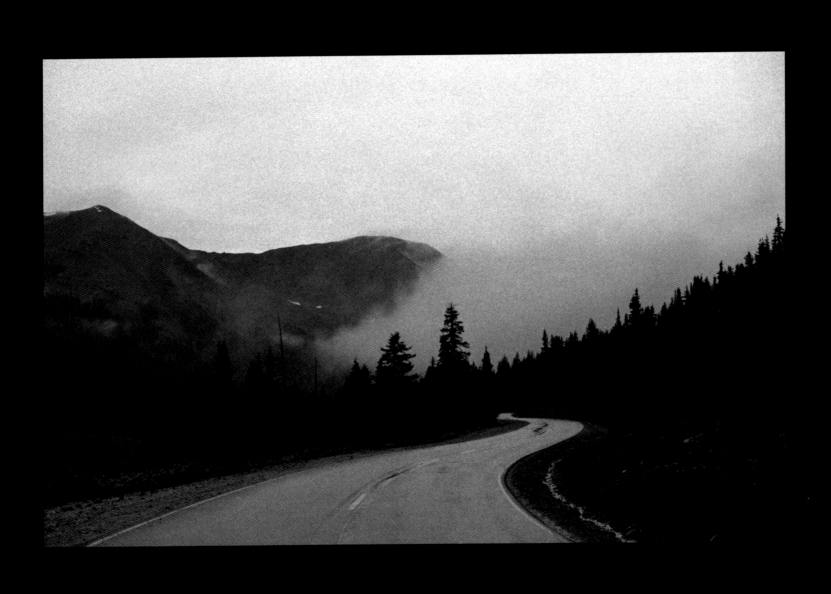

I get into my car and drive. I'm not going to get something or other, I'm going just to be going, I just don't want to be where I was … I'm not waiting for the notion to "Turn back here," I'm waiting for the answer, "Do I turn back at all?"

The usual script runs through my mind. I just keep on going – there's enough gas and food money – until some little town. I rent a room and look for work: at the newspaper, hardware store, the butcher, the tavern, it doesn't matter. I make up a new name and a story about my past. It's this story that kills the most time of my drive. I never try to imagine what the life I've left behind makes of my disappearance, that's just not a part of the drive.

———◆•◆•◆———

…I am asking the same questions
you did the ones you kept finding
yourself returning to as though
nothing had changed except the tone
of their echo growing deeper
and what you knew of the coming
of age before you had grown old…

W.S. Merwin

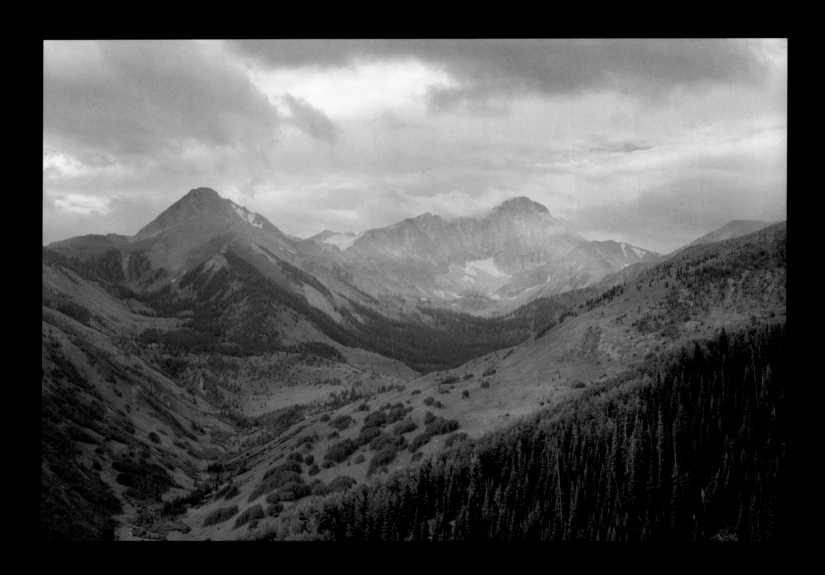

The Capitol Creek road winds up past the trailhead to Capitol Lake into lodgepole pines and to a shallow pond, perhaps an acre in extent, named Hardscrabble Lake. From here there is a splendid view of the Capitol Creek valley and of Capitol Peak.

Pierre, the same Pierre of the Pierre Lakes just East of Capitol peak, believed heaven on earth to be just as possible as heaven anywhere else. He preached this message to the poorest in the community and they moved to this pond to build that heaven with hope, faith and love. With or without these sweet ingredients there is no tomorrow in an earthly heaven without food today.

Pierre's plan was to build a beaver ranch and sell to the growing fur market. Because things did not go well with domesticating beaver at this altitude they prayed a lot, exhorting their God to honor Pierre's promises. It did not work and they succumbed midwinter, bowed and holding hands. A pond deserving of its name.

———•◆•———

The dead lie in a ditch of fear,
In an earth wound, in an old mouth
That has sucked them there.

HARVEY SHAPIRO

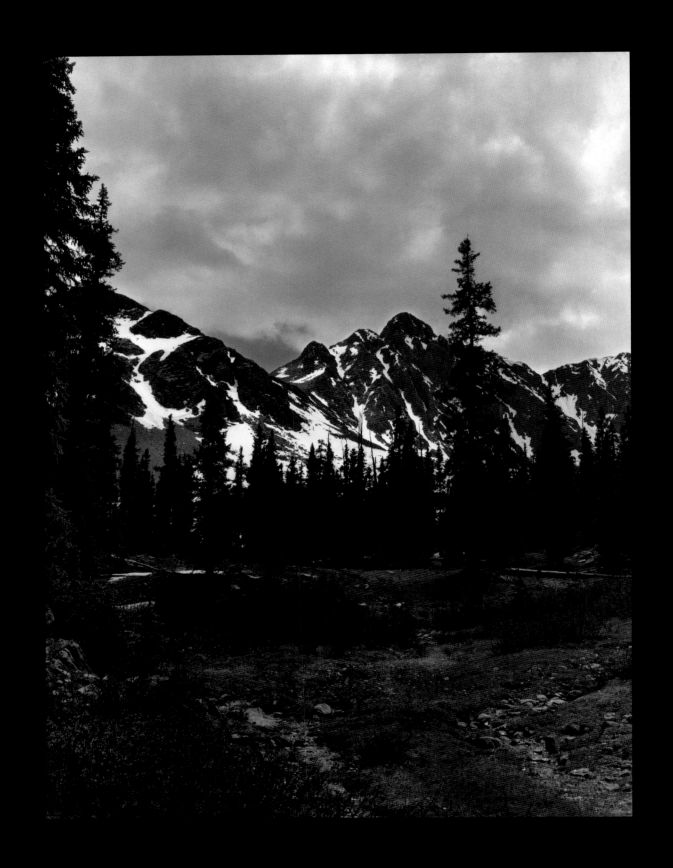

Uplift and erosion, apace, created the Rocky Mountains, Utah's Canyonlands, the Grand Canyon, and all else of the great Southwest. In places the cooled magma is exposed as granite batholiths, and sometimes limestones are found in the interstices that are rich in the minerals that brought the miners here.

In Woody Creek we till the red soils born of sandstone and look Southwest to the granite of Capitol Peak. One valley East of Capitol, Pyramid Peak is solid sandstone, and Lenado, at the headwaters of Woody Creek straddles the silver laden Belden and Leadville limestones.

Woody creatures share an attraction for these mountains. Perhaps a yearning is more accurate, for we are so drawn to hike and climb amongst these peaks. There's a peculiarly human gene that has evolved into this yearning, the gene that has given us the gift of migration, the gift to surmount and survive well in these mountains. George Bernard Shaw said of evolution:

> *When its whole significance dawns upon you, your heart sinks into a heap of sand within you. There is a hidden fatalism about it, a ghastly and damnable reduction of beauty and intelligence, of strength and purpose, of honour and aspiration.*

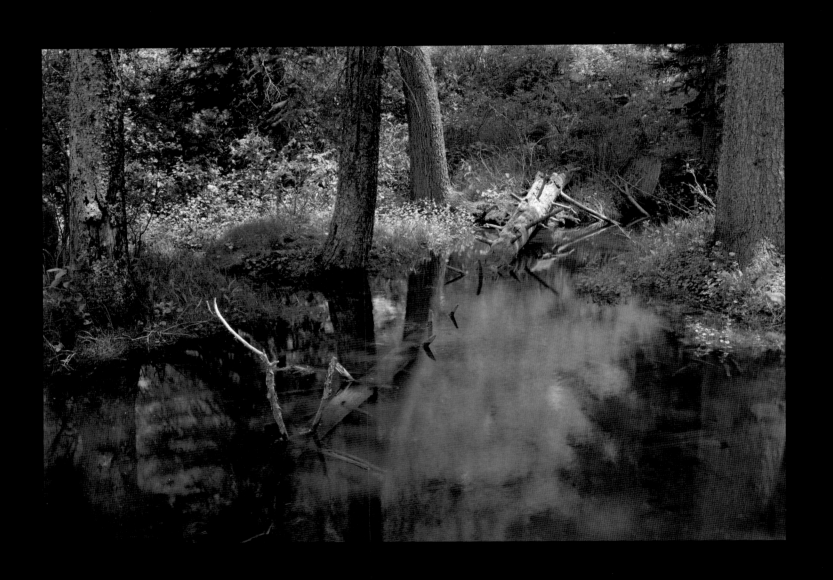

Angelina studied hard to become a teacher. The sisters are kind but firm with her as they expect her to become kind but firm with her future students. Sometimes it was kind and firm, or even kind yet firm. Whichever way said, the word firm was drawn out.

Our Lady of Mercy convent included a slice of land that runs South to a brook in the woods. After class and before vespers Angelina liked to go down to this particular spot and pick an item or so from her wonder bag. She had learned that if she opened the wonder bag to select an item or two, all the rest spilled out and had to be wondered about too.

There were trout in this brook, and if she sat still long enough they ignored her and did what was natural for them. She wondered what was on their minds and did they have beliefs. She wondered if a trout would go to heaven when it dies, and would the mayor or her uncle be there.

———◆———

I am longing to sit by the banks of the river
There's rest for the ones by the evergreen trees
I am longing to look in the face of my Savior
And my loved ones who have gone, they are waiting for me.

LESTER FLATT AND EARL SCRUGGS

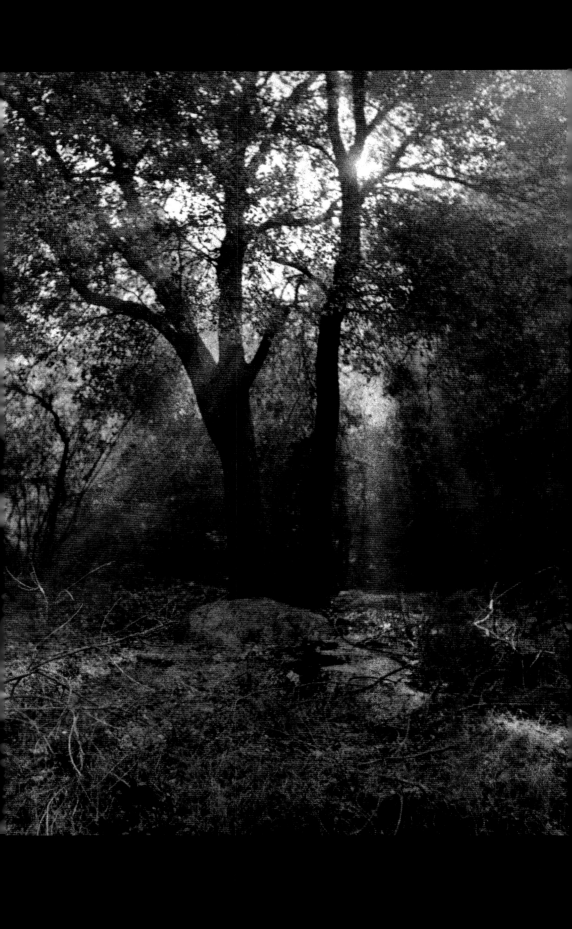

Good morning sunshine,
I do not want your warm light
upon my back,
laying out my own long
shadow
in front of me.

Shine into my eyes
and lay the shadows
of tall trees upon my
feet so that I walk into
your louring darknesses.

For the photographer backlight is an insurmountable opportunity.* An exposure which provides details in the shadows is too long to avoid over-exposure in the highlights. The Catch-22 results in either no shadow detail or washed out highlights. Just as, looking into the darker corners of my life I lose all discrimination of the brighter side.

Photographers have an easier time managing the midtones, the grays. The things that I know how to manage, my clearer choices of the menu of life, are all in the midtones; like the temperature of my morning tea.

*PoGo

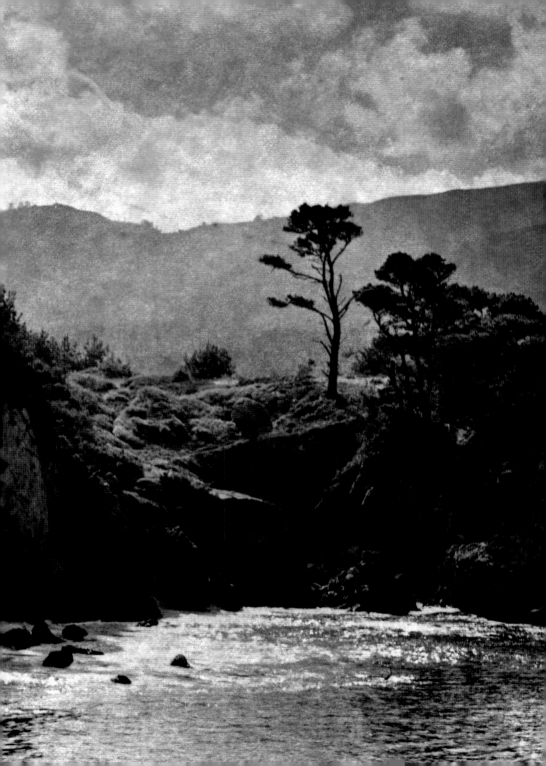

Edward Weston photographed here, Blue Fish Cove on the coast near Carmel. I did too in my loneliness. Not knowing who to be at twenty, I chose to imitate Weston, as you see. I hauled around a 5 x 7 view camera and tripod, loaded film holders, amidol and all that $f64$ stuff. With the camera or in the darkroom life made a little sense and had some meaning and purpose. There was, however, the rest of the time … it was difficult to create the rest of me that wasn't Edward Weston.

Even then I screwed with what the negative brought to an image and to its ultimate print. There were paper negatives and wet transfers to Kodalith … messing around with who I was by messing around with the images I made. We are our choices, our own messing around.

———◆———

You step in the same river once only for an instant.
Panhandle time with the bruised fingers of what might have been.

JIM HARRISON / TED KOOSER

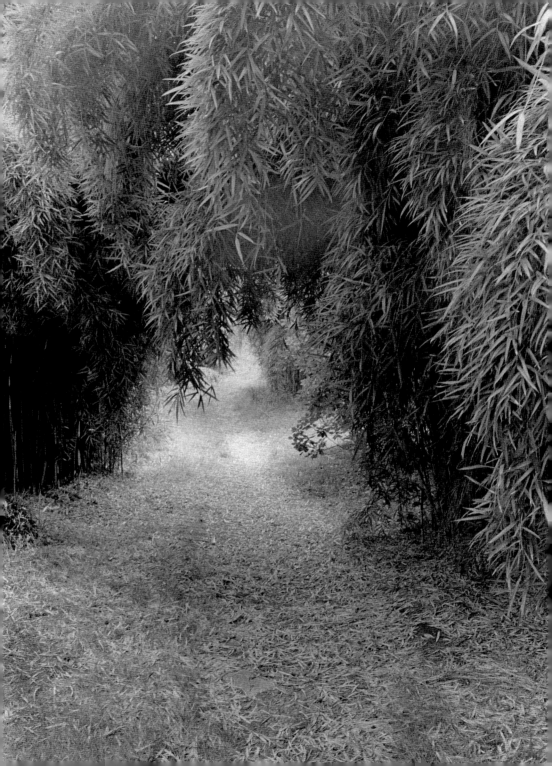

Among these trees and along this path we invented the childhood game we called "Shriek." We treasured our game and were so pleased with it that we assumed that our own children would play it, and they would teach their children, and it would always be the same here in these trees. And it came to pass.

When they were young we played Shriek along with them and cheered their emerging skills, knowing they would do the same with their children, and their children with theirs. We can but don't yet really understand the appetite evolution has gifted us that we must pass on our genes. Where and what to call this more subtle appetite to pass on our games, habits and culture, whether good, bad or ugly; silly or savage?

———◆◆◆———

One should never underestimate the pleasure we feel from hearing
something we already know.

ENRICO FERMI